T0161450

TABLE OF CONTENTS

BRUCE CONNER

CONNER

THE AFTERNOON

INTERVIEWS

BRUCE CONNER
The Afternoon Interviews
©2016 RE/Search Publications
ISBN 978-1889307-21-3

PUBLISHERS/EDITORS: V. Vale, Marian Wallace
COVER & BOOK DESIGN: Marian Wallace
INTERVIEWS and PHOTOS: V. Vale
RE/Search copy editors, staff & consultants:

Jane Knoll
Natasha Boas
Jeff Gunderson
Judy Sitz
Seth Robson
Raymond André

Jerico Garcia
Kiowa Hammons
Robert Collison
Andrew Bishop
Emily Dezurick-Badran

*Please check our website or contact us to find
out about our full line of books and media.*

RE/Search Publications
20 Romolo Place #B
San Francisco, CA 94133
(415) 362-1465
info@researchpubs.com
www.researchpubs.com

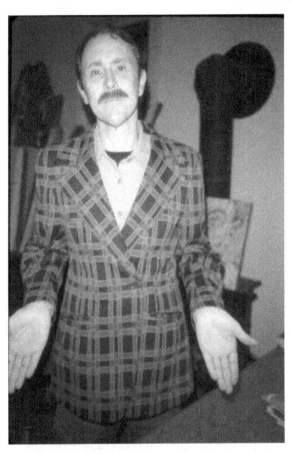

BRUCE Guldner CONNER (11/18/1933–7/7/2008)
was born in MacPherson, Kansas. He has been a
filmmaker, photographer, assemblage creator,
sculptor, philosopher, painter, conceptual artist,
post-Duchamp activist, and more.
He moved to San Francisco in the late fifties and
became associated with the Beat movement.
In the late seventies, V. Vale gave him a
press pass to take Punk photographs for
Search & Destroy magazine…

TRUTH OR DARE:
THREE DECADES IN CONVERSATION BETWEEN
BRUCE CONNER AND V. VALE

One of Bruce Conner's biggest fears, and perhaps our own, was that a museum retrospective might *declaw* his work or a curatorial catalogue essay might defang his intentions. Possibly worried that his life's work might suddenly be neutered by its own culture-making desires and trapped in institutional and avant-garde historical frameworks, Conner developed the effective strategy of tricking us into believing what he showed us. Yet the confessions he makes to V. Vale in their three-decade-long conversation may be the ultimate revelation.

So it is with great gusto and the pride of a native-San Franciscan weaned on the *Industrial Culture Handbook* and the mythological Mabuhay Gardens, that I introduce this heretofore unknown and unedited ten-part interview published by RE/SEARCH in honor of Bruce Conner's out-law spirit (1933 – 2008). Until today, Conner's contrarian and secretive artistic production has balanced precariously on the fringes of the art world. To shed some light on the legend on the occasion of the 2016 posthumous Bruce Conner retrospective entitled "It's All True" organized by MoMA New York and SFMOMA, V.Vale has finally decided to share this original interview with the public.

How often do two San Francisco greats come together like this and let us in on their honest exchanges? Artist/filmmaker and founder of the Rat Bastards Protective Association Bruce Conner and publisher/Punk historian founder of *Search & Destroy* V.Vale are both slashers, showmen, form-breakers, polymaths, pranksters, high potentates and countercultural icons. This rich and inestimable conversation took place in bits and pieces, over phone calls and during café talks and certainly in analogue with tape recorders over thirty long years. Like the rhizome (the multiplying stem systems of plants), BC and VV's influence on artistic production has spread and infiltrated across time and space, inspiring experimentation in many genres with their signature mash-up of classic, iconoclastic, do-or-dare San Francisco countercultural verve. As V.Vale promised Bruce Conner thirty years ago "I will print every word you say" including such madcap passages on vegetarianism, Jane Fonda campaigning for the Dead-Kennedys' front-man Jello Biafra's SF mayoral run, parenting, the pre-Beat publication *Neurotica,* Zen slapping, hating the word "hippie," psilocybin and LSD, "The Prisoner" [TV show], butter, Negative Trend and sushi. The series of interviews delivers Conner's and Vale's voices in unadulterated form.

Natasha Boas
San Francisco Art Institute
September 2016

RE SEARCH. from RE/Search Publications

• • •

Bruce Conner: So what is this terrible news that you want to write a piece on Bruce Conner?

Vale: I am writing one!

BC: For what reason would you want to do that?

V: Why not? Why does anyone write a piece on Bruce Conner? Because he is one of the most important artists, not only in San Francisco, but in the world! In the sixties, your film *A Movie* was one of the most consciousness-raising films ever shown, especially to young people and college students.

BC: Do you have a place to publish such a thing?

V: *We're* publishing *Pranks 2*—

BC: And this is supposed to be about more pranks?

V: Well, it's more about a mentality: a philosophy and an outlook. Your film, *A Movie*, makes you realize that reality isn't what you think it is—

BC: Ha! I think you ought to quote yourself on things like that!

V: I will. But it's true. And I also realized that you had captured some really horrific moments in terms of the people in the footage—the anonymous people and things that happened to them. They probably suffered internal injuries, broken bones, died, whatever—but yet, everyone in the audience was laughing! You somehow managed to combine laughter and

humor with catastrophe.

BC: Well, *A Movie* starts out with classic "comic" events. Bit by bit it makes it clear that people are really getting hurt here. At a certain point it changes; stops being a laughing matter, and everybody gets pretty quiet.

V: Well, it seems that you have definitely destabilized, and contributed a lot of Surrealist thinking, to many onlookers of your art. I think a lot of the art you've done has really been pranks. So let's talk about the idea of your art as pranks—

BC: Well, what in the world can I possibly say after I say, "I'm sorry."

V: Like, "I'm sorry I changed your perceptions of the world of film."

BC: I could say: "I apologize. I have really bad manners. It's been a big mistake. I hope you don't ever take any of this seriously again."

V: "I'm sorry I did a paint-by-numbers version of da Vinci's *Last Supper* and showed it at the de Young Museum of Art"—

BC: Yes, absolutely.

V: And, "I'm sorry I took all this rotting material and made all these creepy assemblage-collage 3-D sculpture things and tried to pawn them off as 'art' on you, the gullible public."

BC: Absolutely.

V: I remember when I first saw some of those

they looked absolutely creepy, and I then had to "process" it.

BC: Oh, you did? How did you process it?

V: I went, "Wait a minute—this is 'art'?"

BC: [*laughs*] Well, that's just because it was in an art gallery or an art museum, probably. People just jump to those assumptions, don't they?

V: Well, your work certainly makes them *think* a little, rather than just going, "Ooh, that's beautiful."

BC: But I like it when they say *that* about my stuff, too!

V: Of course. But then, creepy things can be beautiful—

BC: I guess so.

V: Stuff that's old and decaying and drenched in a kind of apparent nostalgia—although I may not have been alive in the era when it was originally produced. I think you got a lot of your art materials out of thrift stores—

BC: Oh, I got it out of the *entire history of the United States*, I'm sure.

V: You know, pranks are *supposed* to be confusing and discombobulating—

BC: Some of them could be a knock on the head that makes an immediate revelation.

V: Oh, the "zen slap" they call it. But don't you have to be a "zen master" to be able to pull that off?

BC: Well, I don't know if you have to be in the club!

V: Oh, the "zen master *club*."

BC: That was a pun. But if I use all these *non sequiturs* and puns, then I won't be able to say anything. No one will talk to me anymore. Nobody will talk to me after that, anyway.

V: I don't think there can be any end to the invention of puns and *non sequiturs*. If I thought they had all been said before, I would be very sad indeed.

BC: Well, you know, when I did my show *2,000 BC,* I saved all kinds of comments and reviews. On the same day there would be a newspaper review saying I was an egomaniac and think I'm Jesus Christ, and in the same city another newspaper article would say that I'm a humble person and generous and self-effacing.

V: Well, you must be all that, then. You're protean—

BC: [*laughs*] But I also remember reading that one reviewer said I was a *realist* and another said I was a *Surrealist*. So the terminology doesn't mean too much to me, except to witness how other people come up with different points of view all the time.

V: Well, here's what pranks are about: they are an attack upon authoritarianism, particularly this extremely narrow version of "reality" that people like President George Bush would like to think is the way the world really is, but—the world is *not* that way. I remember seeing some of your art that had cobwebs and looked really old, and it looked kind of creepy, actually—

BC: Yeah, it looked creepy, like an old horror movie.

V: Yeah. And I remember seeing that in SF MOMA, and I didn't know what to think, except that I found it fascinating because I didn't know what I was seeing.

BC: Well, there are a lot of things that you could pick out that I've done that can be seen in certain ways, but they're designed to be seen in *many* ways. And so, this is what keeps me amused. When I had that traveling show with all the variety of work that I've done, the comments that people came up with were a full compendium; **you could fill up the *United Nations* with different points of view about what Bruce Conner's work is**; what it means, what he's doing, who he is...

The human mind is always transforming things, and I think that's maybe one thing that perhaps you're talking about when you say *Surrealism*: you're always being surprised, one way or another—*I* am! If I were bored all of the time, of course *that's* interesting: just looking at a blank wall and nothing's happening— [*laughs*]

V: But for how long?

BC: Well you know, not very long. **One thing that I'm not too enthusiastic about is becoming "the septuagenarian pet of today's avant-garde."** I did one interview and the guy said, "Oh, you've inspired *so many* other artists! You did this at a certain time; nobody else was doing it," and he mentioned a bunch of names—I don't know who they are; *some* of the stuff I've seen.

But a lot of the time, my feeling is: I get bored when I go to places when somebody sends me announcements for shows or I see reviews of exhibitions, and they're treating it like, "Hey, this is hot new avant-garde stuff!" And I look at it and think, "Gosh, even me, or people that I knew, were doing something like this in the 1950s and

the 1960s! This is academic old-fashioned stuff!" And of course it is, because it has full support of the art establishment. And they've got huge economic markets behind this stuff. But I don't know why it does this. I try to avoid it as much as possible. Of course, I retired in 1999.

V: I didn't know that. Was there an official announcement?

BC: I've been telling people. I stopped signing any new work. I sign old work or I sign work that is an extension of older pieces. I had some tapestries shown recently at Gallery Paule Anglim in San Francisco, and they are an extension of some concepts I worked on in wood—engraving collages and illustrations of the *New Testament* and other things. I did little tiny collages, about 5" x 8", and then I had the opportunity to work on them on a computer—

V: Oh, you got into the computer age? Wow!

BC: So you didn't see my tapestries, then?

V: No, I didn't even hear of them—

BC: They were here and gone, then. But anyway, they're eight feet tall. I think Paule Anglim still has one of the smaller ones in her office. But these started out being those images that I did very small. And Don Farnsworth over at Magnolia Editions in Oakland (you can see some of these things at www.magnoliaeditions.com) and I were working on the reorganization of photographs that I'd done in the seventies; some Punk photographs, drawings and other things, with him making prints and working on the computer with Photoshop.

Don wanted me to do a tapestry, because he's done these huge tapestries—I think that some of them were on view in Walnut Creek. There was a huge tapestry show

there of all the different stuff that he'd produced. He shot these weavings, and what I found was that when you enlarge these images, it wasn't a *pure* reproduction, because if you enlarge something that's very small into something very, very large, it's got all kinds of debris… Things that you thought were lines are not actually there.

So I would have to spend a couple of months on the computer re-doing every line, cleaning up everything in between the lines, and sometimes moving things around or deleting or adding things to the image. And then when it was finally completed, we could go through another process with his computer set-up where it's all intricately coded and worked out so that the messages could be put into the weaving mechanisms of a Belgian tapestry company that's been in the same family for generations. They seem very different, but they're really an extension of the same pieces.

One of the points that I've had in my work is that I don't consider the work *finished*, even though it has a date on it! Like all of those collages and assemblages, I expected to keep changing them! But then when *somebody else* had them in their hands—! They gave them away, or they ended up in a museum, and they wouldn't let me touch them! [*laughs*]

Of course, *they* had touched them, they had changed them, time had changed them—I expected all that to happen, but I had expected to reorganize them. So I didn't have a big show surveying all of my work for a long time. I had had discussions with at least three or four museums: San Francisco Museum, Museum of Contemporary Art, University of California Art Museum, and one of the conditions I had was that I wanted to bring these pieces "up to date"—that's the phrase I used—and that I wouldn't drastically reorganize them; I would try to keep them as close as possible to what they were.

Their objection was: "It's not your property. You can't touch these. The only rationale we have for any changes

to take place is if the owner claims that there's damage."
And then you collect from the insurance company and
then *they* hire perhaps the cheapest, most ineffectual
conservator to restore the piece, based on a *photograph*,
which of course may be of a totally altered condition. And
only a conservator can touch them—not me.

They get scared of artists restoring their own works
because occasionally—who was it? Maybe it was Hans
Hofmann? They wanted him to restore something, so he
just redid a totally new painting on top of it! And they
didn't like that; they wanted the old one! But *I* had never
done that.

In any case, the Walker Art Center agreed to this. I
always had to be working with the conservator before,
during, or after, and sometimes I'd be left totally alone.
But they figured I was qualified, after all these years, to
make those judgments. But it's an industry and it's a com-
pany—all a bureaucracy.

V: Right, and the Walker Art Center actually let you?

BC: Yeah, well I worked on pieces later in different situa-
tions. The point of view changed a little bit; I was able to.
I of course had to have permission from the owner. And
when I first brought this up with the San Francisco Muse-
um when Henry Hopkins was the director, they wouldn't
even do that—they wouldn't even ask the question!

What I wanted them to do was to exclude anything
from the exhibition that I decided did not properly rep-
resent me—most particularly these type of pieces. Or it
could be something else: a drawing that wasn't by me
but attributed to me—something where somebody had
altered a painting or changed the size or something... It
sounds reasonable to me, but I wanted to be able to reject
any of these assemblage pieces that I felt didn't represent
me, and that had been altered so much and which I was
not allowed to touch—that if they requested something

and I'd made that decision, then they wouldn't put it in the show. They refused to do that. *They* are the people who decide. So I've seen some conservation where people have done some *unusual* things not based on what *my* intent was. So that's what's going on now.

V: Now I think you said that you are too smart to be labeled anything—

BC: But I am all the time!

V: Yeah, but you don't do it to yourself; others do it.

BC: Well, *sometimes* I do, but I usually change it after a short period of time.

V: Exactly! And you said yourself that a big motivation for a lot of the art you've done is to surprise people, and maybe even *yourself*. Don't you think, "Well, they're expecting me to do more of this. I think I'm not going to—"

BC: Well, I tried to review something last night with my wife, Jean. I said that basically, in the early sixties I stopped signing anything. **I wanted people to look at the work itself as a phenomenon with nobody's *ego* stuck on it.** Part of that time, at the most I'd put my name on the back—not necessarily a signature.

But then a gallery where I was occasionally in group shows in New York—the Alan Gallery—the owner said, "Well, you need to have your signature on the front so that the collectors can see it." So I would put my name as small as possible using a very, very fine-point crow-quill pen, and I'd put it in the most obscure place.

Of course, when I sent those oil paintings to him, he couldn't find my signature! So I had to draw a little map for him: "It's two inches from the lower right-hand corner

to the left, and one-and-three-eights inches up." *Then* he could find my signature and point it out to the collectors.

But I got tired of that around 1960 or so and I stopped. I did give Charles Alan permission to sign the pieces if he wanted to. He said that he had practiced, and that he could do it very well, but he didn't *want* to do that. And then I gave him a rubber-stamp with my signature and told him he could rubber-stamp my pieces, other people's work, telephone poles—anything he wanted to! But he didn't really use that, either.

After about three or four years, I decided to start signing things again, and then after a year-and-a-half I changed my mind and stopped signing again. So all except maybe a year-and-a-half during the sixties, I didn't sign anything! But then I signed things later, and I usually kept all the pieces that were *unsigned* for a period. Somebody might have a piece and then they'd ask me to sign it, and I'd say, "Well, if I sign it, it's going to devalue the piece because it will be unauthentic." But I *would* sign it, and then after a while I think I ended up signing all of them.

In 1999 I started working with various assistants (since I had retired), who would do inkblot drawings and other works, and they were anonymous [Anonymouse; Anonymous]. Recently there's been "Emily Feather," "Justin Kase," and other anonymous artists. And I've had shows where I've showed, say, a DVD of something of mine in one room at a gallery, and all those individuals were having shows of their inkblots in the main gallery. And then people would review the show and say, "Well, these are really done by Bruce Conner!" And I'd tell the gallery, "No, you can't let people have this misunderstanding; they're not by me! They're by these other entities."

Emily had a show last year—I think it was March or April—at the Michael Kohn Gallery in LA. The gallery decided to change the prices and didn't consult me; the gallery consulted another gallery in New York that shows my work and these various people that I represent. I was

asking them for a price list to make sure that the titles and dates were correct and everything was the way it was supposed to be, and I didn't get it until a week-and-a-half after the show opened. So when they did send it, the prices were doubled!

I called up and asked, "What happened?" They explained what I had just said. They said, "Well, people have already shown an interest, and up to this point they can buy it at the pre-order price." Because I had been talking to somebody and told them that I'd give them a discount off the price, but now it was way *up there*. And I said, "Well, gosh, you still have some old inkblot drawings by Bruce Conner; people want to buy those instead of Emily's," and they said, "Oh no, we're going to double those, too!" I said, "Either I'm going to be very very rich from selling these in a year, or I'm not going to sell a damn one!" They haven't sold any.

V: You haven't?

BC: No. They haven't sold any of Emily's pieces since then, and I haven't. They sold some to a gallery when the price was going to go up—at the pre-order price. But you know, that's disappointing. I don't like it when people make pieces and then they just get shoved into a drawer and nobody has them, and this seems to be pricing a work beyond its—I don't know *who* buys these kind of prices!

It's like buying a brand-new car. I don't know lots of people who buy brand-new cars every year—

V: No, they're too expensive.

BC: Well, there have been some other things sold, but the economics [*sic*] has dropped, so I decided that maybe we should even things out as far as "Emily" and the rest of them. The only identifiable person prior to this time that they represented was Bruce Conner! So I proposed to my

wife last night at dinner that I should go back to my fundamental root values... [tape ends; turn it over]

Well, now you're getting to the punchline! And you've lost it.

V: You started erasing your signature from all the works that you've signed—that's what you said.

BC: Well, that's what I was telling Jean at the Japanese restaurant: that I should reaffirm those basic values that I had in the fifties and sixties of letting the work exist for what it is: as an anonymous or pseudonymous or *whatever* work, and get rid of my ego. People are always trying to get rid of their ego—well, you don't have to, but you don't have to put it everywhere all the time, either. So I suggested that I should start erasing my name off all the works that I currently have. It would be a little more difficult to steal back the ones that belonged to other people and erase them...but Jean didn't like the idea.

V: She didn't?

BC: No. I called Michael Kohn last night—he's been not feeling very well, and to suggest this didn't help his evening at all! He said, "So why the hell would you want to do *that*, Bruce?!" I said, "Well, I just told my wife that I wanted to reaffirm those basic values that I had in the fifties and sixties, and that I made a mistake signing all of these things." That didn't make him happy.

I decided that it probably would be very awkward, because there are a lot of things that are framed and a lot of things in galleries, and I would have to get them all shipped back to me and taken out of the frames, and erase the signature, and get them back into the frames. It could be such a big campaign that it would really be a pain!

V: But what a piece of performance art!

BC: Well, I told Michael that people would think this was like conceptual art or something. I celebrated the death— well, the *end* of conceptual art last December at a dinner I had, and I said, "There were these people who want me to be avant-garde all the time." Well, shoot—you're just living your life; I don't know what this point is. There *is* no avant-garde, from my point of view. It doesn't exist! What's avant-garde *in relation to*?"

And then of course **there isn't an adequate history of the avant-garde: what people do just *disappears*— because nobody documents it.** And then when the people who wrote the document turn it into nothing but words and call it "conceptual art," then *that* is considered "avant-garde art." But one of the reasons I get disenchanted with a lot of so-called avant-garde art is that it looks like it's fifty or sixty years old to me!

V: Right!

BC: So then I said, "Well, maybe I could do something else, like keep the signature," because I sign checks and sometimes sign books for people, and they have value... that's just money-changing sort of stuff. If we just want to do money-changing, I could efface the artwork and just keep the signature. But I don't think it would be appropriate for me to maintain my position as an avant-garde geek if I were to erase the artwork, since Rauschenberg did that with a De Kooning drawing way back in the 1950s or so, so that wouldn't be avant-garde *enough*, since everybody knows about it. Or I could paint it black, but Wally Hedrick did *that* (and who knows who else did). So perhaps another solution would be to take reproductions of blue-chip artworks by Picasso, de Kooning, Jackson Pollock, Keith Haring, and all those people, and paste them over my own artwork, keep my signature, and sell that! But I thought that was still too cute.

Then I suggested that we *cremate* the artwork and put

them into one of those varieties of containers they have for human ashes—if you go to crematoriums, you'll see these urns and a photograph of the person. So we could have a *photograph* of what it was, and then the ashes inside, and that would take care of a lot of storage—some of these things are so big and difficult to move around—and we would just keep the *spirit* inside of the container.

By this time poor Michael was really fading away. He hasn't been well for the last couple of weeks, and it was eight o'clock at night and he had to help his daughter with her homework, so he probably thought I was taunting him... Maybe I was! So then I said, "Well, what I could do is take it with me when I go, because I expect to be cremated, and then I could cremate all the artwork, too. But they probably have laws against this sort of thing!"

So that's the latest commentary. Of course, I'm doing absolutely nothing, because—

V: Because you retired in 1999?

BC: Well, you know, physically I don't have much energy and—

V: I'm sorry to hear that.

BC: You know, I only have a few hours in the day and I'm wasting them talking on the phone here!

V: Oh, no you're not! It's going to influence people!

BC: Well, okay. Let me tell you something else that is upsetting people right now: my films are no longer available for rent.

V: Oh my god!

BC: I decided this fall that I was not going to make any

new prints of my films at all. It's too much of a hassle and I'm sick and tired of looking at *A Movie* for the 30,000th time—which I have to do whenever it's shown, when I show it, or whenever I review the prints—again and again and again.

So, I had films with Canyon Cinema and I told them that when the prints were "out," that's going to be *it*. I also had gotten elected to the Board of Directors, and initially I was the only one that took it seriously that they might be going out of business. And of course I've been a bad guy from their point of view because I bring bad news, you know: "Kill the messenger!" In the last year they've been losing a thousand dollars a month. They are not a non-profit organization because it's run by the film-makers who profit from the films that are sold there and rented there. So they can't be a non-profit, but they've always thought and acted like they're a non-profit. And they are running out of space.

So I had big fights with them about asking people, "Would you really let us return some of these films that haven't been rented for five years, so we can have more space?" They didn't want to disturb people. We also wanted to get across to them that we were in economic difficulties—Canyon is locked into a lease that goes through next year which is at a higher rate than the surrounding rentals, and so the expenses are more than the income. And I said, "Look, we have to get organized to close." Because this is a corporation, and when you close a corporation you have to pay off the debts and you have to return materials that belong to people—they have 3,000 films! So if they didn't set aside the money to pay for the closing, and deal with this, and understand what it is, then the creditors could come after *me* for my past income, and they could take my films that are at Canyon Cinema as assets. A lawyer told me that if you don't pay off your debts, the court can appoint a trustee who uses a "blunt instrument" to pay off debts—this person doesn't care about

anything except paying off debts.

One thing that they *could* do, is that if they couldn't sell or make money off the films themselves, they could take the film off the reels, sell the cans and the reels, and melt down the films for the silver content of black-and-white film. I told this to the president, who told me that *no way* was this going to be on their agenda, and that they were going to talk about trying to get donations—but they're not a non-profit!

They want people to give them stuff; they don't want to stand on their own four feet. And I said, "Well, I'm concerned about myself as a filmmaker." He said, "Well, maybe you should resign from Canyon Cinema." And I said, "Thank you, that's exactly what I'm going to do." And I wrote my letter that night: I resigned from Canyon Cinema, my films are going to be supplied to the people who currently have rental requests, but no new rentals will be taking place, and they're being returned to me.

V: Well, at least your films will be saved.

BC: Perhaps. I hope they last as long as next May, because that's when the last of the rentals are coming up. But they're still losing a thousand dollars a month, and they said they were going to start a committee to figure out what the closing costs are. However, I don't believe that any of these aging hippies are going to agree to close this corporation at all! And the worst possible scenario will take place.

V: I agree with you, but it's so funny to hear you say that, because I guess you must never have considered *yourself* a hippie, Beatnik, Punk, or any of these underground movements that you've been a part of.

BC: Well, I didn't call myself that anymore than a Sur-

realist. There were other people who called you that. **It's always *somebody else* that's doing the name-calling.** When I first heard somebody say that there were these people down in the Haight-Ashbury that called themselves "hippies," I couldn't believe them—my jaw dropped! *Hippies*? People who are hip don't call themselves "hip," and "hippy-dippy" is jazz vernacular for people who think they're hip and who are not! This is back from the 1940s: "Hippy-dippy." And so here are these mindless schmoes going around saying, "I'm a hippie."

And of course during the so-called "Beat era," all kinds of people were being called "Beats" because it got them in the *door*; at the poetry readings, it got people to buy books, and it got people to go to art shows. Wouldn't a poet admit to being a Beat if it meant they were going to be published, and if they didn't admit to it, they would not be published? Of course! Everybody was jumping up and saying, "Yeah, I'm a Beat!" But I never called myself a Beat or a hippie—

V: Or a Punk!

BC: Or a Punk. Here I am, for all intents and purposes, as far as my position here and where I live in San Francisco, **I'm a middle-class, mainstream person who is an artist due commensurate respect and acknowledgment...an aging statesman of the arts.**

V: I agree.

BC: Oh. Well, I've gotta go do something else!

V: Well, Bruce, thanks so much.

BC: So you're going to write this and put it someplace?

V: Of course! It's all going to appear in print, and

you haven't gotten watered-down or lost your marbles—you're keeping an edge to the very end, it seems to me.

BC: Well, it isn't a prank. Pranks are sort of tricks on people that invariably seem to hurt them.

V: Sometimes...sometimes they enlighten them.

BC: Well, I don't know—look it up in the dictionary! You know: if *you* want to *extend* the definition so that it means anything that surprises people or isn't what they expect... But a lot of the times when I've been viewed as purposely doing things to annoy people, it's not my intention at all, and I'm sometimes very surprised!

V: In a different way than you wanted to be.

BC: Well, I've been reading recently in the last ten or fifteen years that the reason why I was doing all of these assemblage things was because I was opposed to abstract expressionism. And that's not true; I love that stuff! But *I* wasn't doing that, I was doing something else. Just by the fact that I was doing something else, these people tried to turn it into an oppositional, confrontational relationship.

V: Right, indeed. But you know, one of my favorite things that you did—and don't take this the wrong way—was *The Last Supper* paint-by-numbers painting that I saw at the de Young. I didn't know that you'd made that.

BC: Yes, I did.

V: That's cool. I wondered, "Did Bruce *really* paint that, or did he find it at a thrift store?"

BC: I even used *their* paint and *their* paintbrushes, and it takes a great deal of talent to use their paintbrushes and keep within the lines! And I did the colors exactly where they were supposed to be, and the only thing that was a variation was a true mistake, because I'd painted this one section that I thought was dry and I stood it up and the paint ran on one little square of the sleeve off of one of the disciples. So in any case, I gotta go—

V: Okay Bruce, thanks a million!

BC: You've gotta print every word! Bye!

BRUCE CONNER ON TIMOTHY LEARY

V: There are those who think that just giving LSD— disbursing it—was a prank in itself—

BC: Well, [Tim Leary] was pretty sloppy about it. He'd do so his whole sales talk about how [LSD] was a great cure for *everything*—

V: [*laughs*]

BC: Like, he would put some LSD in somebody, and then they'd start bad-tripping, and he'd walk out the door and leave this guy to freak out, and anybody else who felt responsible would have to take care of the guy.

One time he did that over at the Newton Center, and it was to a mathematician at Harvard. And of course the guy is a very structured guy, and this LSD terrified him. One woman who was living there said that this guy was freaking out; he was sitting in this chair in this pantry in the kitchen just terrified of things coming out of the

wall at him and everything, and Leary just said, "Bye-bye!" and headed for the door. The guy got up, picked up a folding chair and hit Leary over the head with it. And she said she'd never seen Leary look so surprised in his life! [*laughs*]

V: The mathematician did that?

BC: Uh-huh—well, that's what he [Leary] unleashed—that's what Leary inspired. There were quite a number of people that would have been inspired to do that. There was one guy that showed up there with his family and his kids and his car filled with all the possessions that he had left after he'd sold his house and everything, and he had been a teacher at some college on the West Coast, and Leary had invited him to be part of this communal life there at Newton Center, and he showed up there, and Leary said, "Oh, guys, we're all going off to the West Indies now; we don't have room for you."

V: [*laughs*]

BC: The guy said, "But I quit my job and you said I could *da - da - da - da - da*..." "Oh, I'm *sorry*. Well, that's the way it is, man, you just have to go with the flow."

V: [*laughs*]

BC: My feeling is that his whole operation there was like an exercise in conspicuous consumption. It was consuming everything—physically, emotionally, and spiritually—and just throwing the dry husks out the window. They ran through something like $80,000 in this IF IF [International Federation for Internal Freedom] organization in about the month-and-a-half that I was there, and absolutely produced nothing—it was just one stupid disorganized disaster after another. Actually, it seemed more

organized, because they always seemed to *do* exactly the opposite of what they said they were doing. So I think there was a real delight in Leary's way of dealing things: to just put people in a crisis situation, and then let 'em *wend their way*... Of course he'd make a lot of snake-oil promises ahead of time. He's just sort of a classic snake-oil medicine man, I think.

V: [*laughs*] Didn't he ever warn people: "Oh, you might have some anxieties during this experience?"

BC: Uh, no; I think his whole idea was...if you read Leary's *The Psychedelic Experience* book, they just sort of start programming you so you *do* have bad experiences! There's all this stuff that's supposed to be read to somebody while they're tripping, telling them what they're looking at, and how they're gonna have a bad trip (and all this other shit). I thought it was a real downer, that book. But *no, no*. I mean, he's like a car salesman promoting a product that was going to cure all the ills in the world, and once you took this little pill you would love everybody, and it would solve all the problems. Of course he was setting himself up to be the high potentate—the guy who would control the whole thing. Very insidious operation....

I think if you were to get together those people that were living at Newton Center, you'd find pretty common ground there. Some people consider Leary to be more endearing than others, but... I don't know; you could probably talk to Mr. Dick Alpert who's now called Baba Ram Dass—if he'd talk about that; I think he'd probably tell you a lot of the same things.

V: Hmm... I thought they were still kind of cronies—

BC: Oh yeah, I'm sure, but they all treat it sort of as a joke. It was like a put-on and a con game, and we were all aware of that and how it was being used as an indus-

try mainly to recruit millionaires. Like, Leary would take acid trips with millionaires with the idea of generating thousands of dollars of donations to this IF IF organization to help run the stuff. So we would put on little shows as being psychedelically aware and loving; millionaires would show up...but *when they weren't looking* it was like outpatients at the mental clinic! [*laughs*] You'd go down one hallway and you'd have to have immediate zen reflexes to deal with whatever kind of psychodrama was taking place at that time—you had to be very adaptable!

V: [*laughs*] I guess it was good survival training for you—

BC: Well, it *wasn't* too good survival training for a number of people. I thought I got damaged from the thing, and there were other people who got even *more* damaged.

I told you about the guy that came back who was like number three in charge—he came back from the Virgin Islands and had to be tranquilized entirely by thorazine because he considered the betrayal of Alpert and Leary to the cause of consciousness expansion, because Leary was aligning himself with the then-current psychoanalytic psychology kingpin of the island whose basic relationship to mental problems was 1940s–1950s shock treatment and lobotomy. And his way of dealing with what he considered this "traitorous" activity—because what they were trying to do was align themselves with this guy because they'd been kicked out of Mexico and kicked out of Antigua and kicked out of all these other places—was that they were going to align themselves with *him* and they would have their IF IF organization on this island with the support of the organization. And he couldn't sway Alpert or Leary away from this. So the way that he dealt with it was: he went in to this guy and asked him to commit him to the hospital, knowing full well that once he did that, that the way he would be treated would be

in this doctor's traditional manner with shock treatment and lobotomies and all the rest of it. And this put an enormous guilt trip on Alpert and Leary, and they all freaked out and this polarized the whole situation and he said, "Look"—basically, by his action, he was showing, "Look. This is what happens to you and your friends and your loved ones if you start aligning with this, because you just can't control this kind of aggressive behavior." So, they got him out of there, sent him back... We got messages at Newton Center that he was playing bad games...and my role before he came off the airplane was to track down a psychiatrist in Boston—a black psychiatrist—and get some thorazine so we could pop these pills in his mouth soon as he got off the plane. Well, he was out from number three in the top twenty, [*laughs*] he was OUT! And he *was* damaged—I mean, this was just too much for him. He was a nervous disaster for at least a year or two.

V: He finally recovered, though?

BC: Uh, yeah, I think his intelligent thing was basically to get out of this Leary–Alpert organization—

V: That's how he survived?

BC: Yeah.

V: You didn't have any "bad" trips yourself?

BC: Well, I think that's a matter of how some people define it. I don't know what that represents but, you know, there were usually some stressful situations in almost every situation.

V: You know Philip Lamantia, don't you?

BC: Mm hmm.

V: He told me that Tim Leary actually helped him out in Mexico—not giving him acid, either; he didn't have any. Philip said he was in an extremely prolonged state of depression and Leary turned up, Mexico City or something; this was really early sixties—

BC: Probably when I saw him in Mexico.

V: Did you know Philip in Mexico?

BC: Sure, I knew him long *before* Mexico... There's a book of his called *Destroyed Works* that has a cover by Bruce Conner. That was written and we determined to have that cover I think back about 1957 or '58 but then it wasn't published till about... No, *wait*: we decided on the cover in '60 and then it wasn't published for a couple of years. And when it *was* published, the piece that was reproduced on the cover was no longer extant because it mispacked it; [*sic*] it was destroyed in shipping.

V: [*laughs*]

BC: Philip was the main person I knew down there.

V: Can you tell me more about Philip?

BC: Oh, I have to do it another time 'cause I'm in the midst of doing my film editing—I've got to get back to it... [end]

BRUCE CONNER ON PARENTING, ETC.

BC: How's all the family there?

V: [*laughs*] Actually, we're reorganizing the whole

place. My bachelor pad for the past seventeen years is
being cleaned out to make way for mother and child—

BC: Yes indeed! You'll find that, as time goes by, that ev-
erything has to be readjusted every six months.... When
the small toddler starts climbing up the bookcases, pulling
things out, drinking everything, sticking everything they
can in their mouth, testing every aspect of it, then you
either—for the preservation of the baby or preservation
of your property—you have to start locking things up, or
securing them, or stabilizing them, or putting them too
high to get their hands on.

**V: Unfortunately, almost every shelf is only filled
with books and magazines—I don't care if they get
pulled down—**

BC: Then they get torn up and food stuck in them—all
sorts of stuff! Drawings in 'em; lots of drawings all over
the pictures... Yeah!

V: Thanks for warning me—

BC: This is the *voice of experience*. And then of course when
they get to around fifteen or sixteen, they'll hate you.

V: Oh, thanks—

BC: You know what that's like; you saw them.

V: Maybe even earlier—

BC: Maybe even earlier. They're getting very precocious—
maybe they'll hate you by the time they're seven or eight.

**V: Or at least by thirteen. Thirteen: they'll go
through their alcoholism phase, then run away—**

BC: Mm… Mm hmm. Where are they gonna run away to—North Beach?!

V: Then they'll run to Berkeley.

BC: Oh. Being political…maybe they'll run to the Financial District! They wanna be right in the wannabes, y'know. It's yuppie world; you have no control over the child.

V: *That* I've already resigned myself to…

BC: You're at the beck-and-call, usually.

V: And, of course, you are the money provider.

BC: Uh huh—well, that helps.… You can't earn too much money right now. But you gotta get them to sign a contract early saying they'll pay it all back.

V: I don't think so.

BC: No. I wanted to ask you about City Lights Bookstore: who to contact there about a magazine?

V: A magazine?

BC: Well, this is a magazine that was going to be printed in 1952 in Wichita, Kansas with things by Michael McClure and Bruce Conner and Dave Haselwood and it never was printed, so this guy in Wichita who still had all the materials got me involved in it and he's printed 250 copies. Now he wants to figure out what to do with them. It's called the *Provincial Review*.

V: Wow—an early Beat-era document—

BC: Yeah, it's definitely a document: 1952. It doesn't

sound very "Beat" though.

V: It should be easy to distribute.

BC: So who would I call over at City Lights? He wanted me to send it to City Lights.

V: The magazine-orderer is a woman named Elaine—

BC: Well, it's one of a kind, actually—

V: Send it to Lawrence Ferlinghetti!

BC: Lawrence I'm afraid will just eat it and it won't end up in the bookstore.

V: Well what about Nancy Peters?

BC: Oh yes, I've talked to her... Maybe I should give her a call and tell her about it, or is that disturbing?

V: You could.

BC: ...It's five bucks. Only thirty-four pages. Send your five dollars to Lee Streiff, 2328 McAdam Drive, Wichita, Kansas 67218. Five dollars a copy, and you can find out what Michael McClure and Bruce Conner and Dave Haselwood were doing when they were eighteen, nineteen years old...pretty adolescent! [*laughs*] Send a check to him and tell him you're hot for the *Provincial Review*—

V: ...What an ironic title—

BC: Oh yeah. You know there was the *Poetry Review* and the *Partisan Review*—that's what it was: it was a take-off on *Partisan Review*. It has a very stylized *moderne* image on the front circa 1950s of a guitar and an *ersatz* chicken

standing next to it.

V: [*laughs*] A chicken playing guitar?

BC: Well, no, the chicken is standing there, and the guitar is standing there, and it's a pen-and-ink drawing by Bruce Conner.

V: Oh, the chicken is a vocalist—

BC: Mm hmm...which came first: the chicken or the guitar?! Anyway, it was kind of a satire on the modernist designs of things at the time, as well. However, there wasn't anything else in it that appears to be a satire. It's full of sort-of naive...*romanticism*. And then there's a bunch of fake ads—actually they're what would have been the *real* ads in the magazine if we'd ever gotten it published. It was going to be published by the writers' club [the Quill Club] at Wichita U, but it never happened. So there's ads for the King's X Drive-In Service, and a bookstore, and Pete's Place for Steaks. Oh, and the Shocker Inn: "Try our Shocker Special at the Shocker Inn!" They had this sort of caricature comic-strip figure which was like a shock of wheat all tied-up with big eyes and grinning face so that Wichita University—the team is called the Shockers—

V: That's weird; that's really weird—

BC: Mm hmm. Yeah, that's the way it is out in Wichita. Weird.

V: What do you call it: "provincial weird"?

BC: *Provincial Review*, definitely. Lots of poetry in here; three poems by Bruce Conner.

V: Poems?

BC: Poems! And actually, poetry that rhymes by Michael McClure.

V: That rhymes? Oh no—

BC: Mm hmm. Bruce Conner's stuff doesn't rhyme at all—

V: He was ahead of his time—

BC: [*laughs*] He just didn't know how to work as hard as Michael did.

V: I think it's work to make rhymes—

BC: *Yes*, it sure is—especially if you want it to *mean* something…and it also says something reasonable—

V: Too much work for me!

BC: Yeah, I wouldn't want to do that stuff. So, are you working on new publications?

V: Yeah, we just finished one called *Zines Volume One*. And as soon as this house gets re-done we're doing *Zines Volume Two*. [*discussion on this neologism*]

BC: Are you doing "vines" [*pronounced "veens"*] ? Then it would sound like it was a *vegetarian* publication!

V: Vines, huh? We try. We don't succeed but we try.

BC: Ah…

V: To be vegetarian, that is.

BC: Well, it's a little tough. I mean, the world is working against you, generally. It's difficult to eat out and be veg-

etarian. For me to be a vegetarian and eat out is almost impossible, because with my "funny" liver I can't quite absorb the protein that well. So I have to eat—

V: And it works?

BC: Well, I eat skinless chicken breast, broiled—

V: Oh, broiled—that's nice—

BC: Yeah, and that's about it. Except for some seafood. Ach, but there's virtually no place for me to eat otherwise because I can't eat any fats and milk products, and oils—

V: You don't eat sushi every night?

BC: Well... I got sick and tired of sushi. [*laughs*] I *did* have some sushi last night, but that's the first time in weeks. But I usually stick to the cooked stuff...the cooked combined with vegetables, because I've heard too much about those little bugs that get into your liver as well, and I don't need anything more running around in there making their home, setting up house, and stealing the groceries before it gets to *me*. [*laughs*]

V: Hey, didn't you go to New York?

BC: That was in November.

V: Well, hey, time flies—

BC: Yeah, I came back sick as a dog and had bronchitis for three weeks—couldn't get out of the house for three weeks. I don't think I travel very well; I seem to get sick whenever I do—

V: Yeah, but you went there in the dead of winter,

probably inadequately clothed—

BC: Well, it wasn't really; it was pretty nice weather except for the last two or three days it started getting cold, and *then* the blizzard hit...the day after we left. That was fortunate. But even before the cold weather came, I seemed to be on my way toward that.

So I'm gonna go see the Beat Show at Minneapolis at the Walker Art Center; it opens June 1st. They're gonna put me on a panel, and I'm gonna call George Herms a "Bohemian," and George Herms is gonna call me a "Beatnik" and I'm gonna call him a "hippie" and he's gonna call me a "Punk" and I'm gonna call him a "slacker." So everybody can understand exactly how the terminology changes over a period of time...if they got anything new to insult people with! [*laughs*]

V: Yes, we must have a continuity in these "slander terms"—

BC: Uh huh, you have to get it across that there's a *tradition*. Do you ever read *Neurotica* magazine?

V: No.

BC: That was really the precursor of all the Beat stuff. It came out of St. Louis, Missouri, and I bought my first copy about 1951 when I was in Kansas City, Missouri. And it had Carl Solomon and Allen Ginsberg and other people published in it, and it was full of satire and Black Humor and Freudian stuff and incomprehensible things and it was called *Neurotica*!

V: Oh, of course, hence the Freudian content—

BC: But it was. They said: "This is a magazine by, and for, neurotics." So it was the most far-out magazine in the

country—

V: Really?

BC: Yes! And I subscribed to it immediately. There I was, eighteen years old, being immersed in this kinda stuff. It's really amazing: the amount of input I had from all this stuff that was going on that I was searching out and getting information about when I was that young—and Wichita is totally isolated, you know. So it was like: any drop of information that was coming from the outside world of this whatever-the-hell-was-happening-wherever… I was trying to grab ahold of it.

V: How many issues came out of *Neurotica*?

BC: I don't know. It went on for several years.

V: Have they ever been reprinted? Maybe I should do that—

BC: It would be a great idea. I sold all my issues when I went to Mexico in '61, 'cause I cleared everything out of my closet and cut it all down to a suitcase.

V: You didn't have parents to ship stuff to?

BC: Uh, well, **my father kicked me out of the house and told me never to come back again** [*laughs*]—that doesn't work.

V: What about your mom?

BC: Well, she was captive in the house and he wouldn't let her out, so— [*laughs*]

V: Oh, right, *that* generation…

BC: [*laughs*] She was the slave, on-call twenty-four hours a day...

V: Right. Well, who has a set?

BC: I don't know—talk to Ferlinghetti, I guess. You could probably contact UC Berkeley Library. There used to be a place on 24th Street—

V: I don't think they're in business anymore: Small Press Traffic.

BC: I would start with Ferlinghetti or UC Berkeley Library... It would be great to see some of those reprinted. I remember one which had a big article on *Struwwelpeter*, this children's book where they do a lot of cutting of thumbs off and everything...talking about all the castration imagery and stuff that's in there...

Ah, I gotta go eat, Jean says.

V: That sounds good.

BC: Talk to ya later... Bye-bye.

BRUCE CONNER ON HIS STAG FILM

BC: I don't think the Stag film thing's very good, though. I don't know what other kinds of pranks would they be? I mean, that was a pretty serious thing: to ruin my reputation as a filmmaker. It *didn't*; it backfired totally. So the prank was a prank on myself. I guess.

V: In actuality, it didn't ruin your reputation at all. I don't think too many people ever heard of that film,

at all—

BC: Well, I had to destroy it because it was obviously doing the exact opposite. [*laughs*] It was giving me a reputation I didn't want.

V: Probably like Andy Warhol's *Sleep*—

BC: Let's see.... What other kind of pranks do people do? Something to hurt people?

V: No, no. Pranks always are about mutating expectations—

BC: Mutating expectations, huh?

V: Yeah. It's kinda hard to explain but basically a lot of them have to do with re-interpreting cultural signals. There's a lot of built-in "scenarios" in life: if you call a doctor, sometimes you plug into a kind of built-in scenario. Pranks have to do with taking advantage of that, changing it...sort of *reading between the lines* of cultural signals.

BC: Ah...that's what it is, huh?

V: But mostly it has to do with mutating expectations... Bruce, you're such a funny guy, I know you've done some pranks in your life...

BC: Like, the process to destroy my reputation as an artist was a pretty good prank. You just got to see it change expectations all the way down the line...including my own!

V: Tell me, what was that Stag movie about?

BC: It was just a beer commercial for Stag Beer. I sent it to this guy in Wichita, Kansas...a Stag movie. He rented

a projector, got all the popcorn and his friends over there, and he called me up and told me all this stuff. They told him how outraged they were. [*laughs*]

So, here's this thing: you see all this film leader going on, and then you see this commercial where they're popping the top on all these phallic bottles with bubbling and running over the top of them, and they say, "Stag Beer!" And you get to see a stag run around. Then it ends in about fifteen seconds, and it takes practically another forty seconds or so for it to start another one. And that went on for an hour!

V: Gawd, you recycled the same commercial—

BC: Well, somebody gave me a whole bunch of stuff, and it turned out this was in the pile of stuff.

V: All these Stag commercials—

BC: Yeah: the Stag film comercial.

V: Did you doctor it; add a soundtrack or—

BC: No, not at all. Kept it real simple. I just thought they would run it thinking, "Well, this is a nice joke—uh, pretty absurd, huh? Let's wait; get around to the real stuff pretty soon." Then they have to run through the whole thing. And it ends up being exactly the same repeating orgasm, again and again. And they weren't happy with it! I don't know if the guy still has it or not. I don't know if he had a lot of respect for that—*it was a lot of work*, to stick all that stuff together.

V: Yeah, right. Well who was this guy you sent it to?

BC: Well, I'll find out his name, but he's a manager of a PBS station down in Texas, now. Well, I sent a brick to

Terry Riley once...

V: How come?

BC: Well, these are just stories, right? I can't tell you now, then I've already told 'em, right? I don't want to tell 'em again—I get used up!

V: Wait—these are stories you're *gonna* tell me—

BC: Well, *maybe*. You told me to think.

V: Yeah, seriously.

BRUCE CONNER ON MEL LYMAN, TIM LEARY

V: You were quoted in a *Rolling Stone* article on Mel Lyman—

BC: Yeah, I was quoted at the very beginning, about God and all that other stuff.

V: No kidding—

BC: So that's about the only comment I've ever really made about it, and it was printed in *Rolling Stone*. But I don't know if that's a prank—

V: I thought it was funny, because he ended up putting on all these other people who would actually be stupid enough to follow him. I mean, a prank in a way is related to the "put-on," and I think anyone who sets up a cult like that is playing a prank on his

so-called "followers"—

BC: Well, you have to differentiate at one point whether it's a prank or whether it's just a...heavy power-play. And at that time, what he was doing was: he was studying Timothy Leary's organization and his power structure, and—

V: Wait a minute—I didn't know Timothy Leary had an *organization*? I never looked at him that way.

BC: He's always had finances and people who have been his associates, etc., etc. There was an organization called International Federation for Internal Freedom [IF IF]— did you ever hear of that?

V: No.

BC: That was a real organization, and Timothy Leary was in that. And their plan was basically: *take over the world through psychedelics.*

V: He was a member, but not the quote "leader" unquote?

BC: Yes he was! Well, you know, it was a deception. I mean, it was always a perpetual deception: that Timothy Leary was not a leader; he was just "one of us." However, whenever you got into the environment where Timothy was, you would find: everybody was doing what Tim wanted them to do, and they were saying what Tim wanted them to say, and it was organized so there was this facade that he was this egoless person that everybody would sort of "channel things through" and he would express the pure soul of his entourage [*pronounced en-TOUR-ij*].

What happens is that, like in our so-called "communal" society out there in Newton Center, there would be a meeting. And before the meeting, for a day-and-a-half

or two days, people would be primed by, uh, associates of Timothy Leary (*closer* associates within the community) as to what Timothy wanted us to do. And that certain people would say, "Look, I'll bring up this subject, and why don't *you* say this other thing?" So when you came to the *meeting*, Timothy was there, and he played his part, which was a sort-of smiling guru guy, right: "Oh, everything's cool; let's find out what everybody wants to do." So somebody would say, "Hey! I think we ought to go to the Virgin Islands and do such-and-such." "That's a good idea. Anybody else got something to say?" "Yes, and I think we ought to do such-and-such and such-and-such." "Well, that's open for discussion." *But*, when somebody would suggest something that had never been proposed before—like *I* did—

V: What was that?

BC: I suggested that… I talked to one of the other guys and and we decided that we wanted to propose that as far as being an emissary of psychedelics—that we wanted to provision a Volkswagen full of hundreds of pounds of morning glory seeds.

V: Were they legal then?

BC: Yeah, and head out from the East Coast and be sort of "Johnny Morning-Glory Seeders" across the country turning people on with morning glory seeds—

V: By the way, do they *work*?

BC: Yeah, they do, but they sorta make you go to sleep; they're not a "high" level… But what happened when I brought this up, and he brought it up: *nobody paid any attention*. Leary didn't hear us; nobody else heard us—

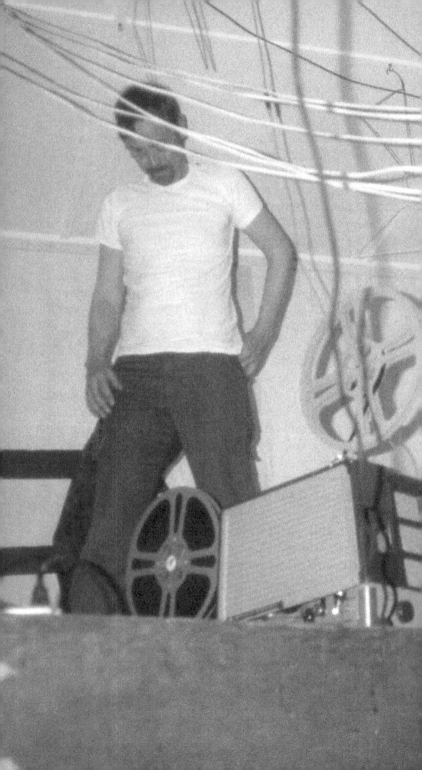

V: Nobody laughed?

BC: Nobody said *anything*. I mean, we were serious about it. So, I think the other thing was that if you were a woman, nobody paid any attention to you, either. So basically the whole thing was run by Timothy Leary and a handful of people who would say exactly what *he* wanted them to say. So does that answer your...that he has no organization? He's *always* had an organization; he's always worked for other people; he's always been after millionaires and other people to support him. First of all it was Harvard, then it was a whole series of millionaires that he recruited to support IF IF and all the psychedelic gumball ideas. He spent hundreds of thousands of dollars, wasting it all—physical and spiritual wastefulness—and you know, then left there and then he went on the show biz circuit doing the psychedelic show—

V: We're talking now 1966 or '67—

BC: Yeah! He was always working for somebody else. Then that gets a little heavy when he gets busted going across the border, and he becomes a self-righteous martyr (which he's always wanted to be, so then that's another source of income because he has to be supported) to his daughter sticking a roach up her pussy and getting kicked out of Mexico so he can get arrested. And then he can't stand being a martyr in jail, and he runs out of this golf-club prison that they have set up for just like him and his other associates. He also has liaisons with the CIA and other institutional organizations for all the people that were getting "offed" and tripped up and really brutalized and murdered during those times... You'll notice Leary never was—he's like—*nothing touches him*. And basically it's because he's one of the good ole boys from Harvard. He was a *Harvard Professor*! And he's worked with the establishment all the way down the line.

So he runs away and he goes off and hangs out with—who was that black guy with the—

V: Eldridge Cleaver?

BC: Yeah, so then he goes over there and goes to work for Cleaver. And so the garbage that's coming out of his mouth attributed to him when he's over there with Cleaver—he's a little Charlie McCarthy doll for Cleaver's Bergen. He's talking about "love is a bomb" you know. He's just like a paid advertising shill, you know.

Then he gets busted and brought back and he goes through all the rest of the stuff and then he goes on the circuit with his old-time vaudeville buddy who busted him in Millbrook—

V: G. Gordon Liddy?

BC: Yeah, they're both basically the same. They're both exploiting their—well, Liddy is probably more sincere in his attitude than Leary—I mean, Leary just has no sincerity at all! And basically, if he didn't live as if he had an income of fifty or sixty thousand a year, he just changes his tune.

V: Gawd. Bruce, I hate to say this, but it sounds like you don't *like* Leary—you didn't approve of what he was doing—

BC: I did not approve of what he was doing at all. I went in to his organization because I felt that his organization called IF IF was probably the most insidious and cynical exploitation that was going on in any of the psychedelic activity. They had it designed basically like it was...it was designed to unduly influence people under drugs so that they would reflect what Timothy Leary and his two or three cohorts wanted to happen.

V: Who were those cohorts?

BC: Richard Alpert, Ralph Metzner, and one or two other people. There's a guy that's now a psychology professor down in Arizona; can't remember his name. Then there was another one that got kicked out of the place because of his objections to the things that Leary was doing.

Their idea, for this IF IF organization, was that *nobody runs anything. We are an egalitarian organization based upon the highest psychedelic principles.* So, this thing is being run by a cell group of five people that are at the center of this organization. That's Timothy Leary, Metzner, Alpert, and these two other guys. They sit around and they take acid (or whatever) and then each of those are an emissary to five other groups. And they go to those groups and they take acid with these people. And then each of those groups that has five people has each of those persons go to five other groups. So, as a pyramid, what you have is a situation of communication and influencing people in the most substantial way that you possibly could, by the kind of pressures that could be done to people emotionally and psychically under the influence of psychedelics. These other people reflect what it is that Leary and Alpert want to do, 'cause he and Alpert were the basic ones controlling the group. You see the pattern with other cults and organizations that end up throwing rattlesnakes in mailboxes [Synanon] and doing all sorts of killing... [People's Temple] killing hundreds of people with Kool-Aid and shit like that.

So, I saw what was happening. I was invited out there after I'd been with Leary in Mexico and they invited me to move into the house. And so I moved in there as a fifth columnist, as a matter of fact, because I didn't want to see this thing...

V: Was Mel Lyman there the same time?

BC: No, he wasn't *part* of it. He just would drop in to the place. He was trying to study how Leary controlled all these people; how he had the power to do all this stuff, and first of all he discovered it was the drugs, and so he started pumping all these people with drugs, and trying to pattern himself as a minor messiah.

You wanna talk about Mr. Lyman, then all of it—everything that he did was something which he was... He just really admired Leary's system.

V: Hmm...

BC: But, the main thing was that really there was nothing for me to sabotage or be a fifth columnist in, because these people—everything that they *professed* to do, they effected the opposite effect. If you'll notice, virtually everything that Leary has espoused has become illegal, or turned into a disaster. It's like it's *designed* that way. It's like his way of doing things.

V: But he did some fun things—

BC: Yeah, you can have a *party*. You say, "Look, my purpose here is to make psychedelics available to everybody." But you consciously manipulate situations so that, as a psychologist (which he's had quite a bit of experience being) you're quite aware of the kind of political and social reactions that will happen, once you evidence a certain amount of public dissemination of extremely unpopular points of view.

I mean, he was proposing that all psychedelics should be legal—however, he sabotaged every possible chance of making it legal.

V: Oh, really?

BC: Yes, indeed!

V: How?

BC: How?!? [*laughs*]

V: You mean through giving it bad publicity?

BC: Well, as I said, everything that he does, he does to sabotage the "system"—whatever system it *is*. And he just sits on top of it, eating the spoils—you know, eating the best of the fruit floating on top of it. And in the meantime, whatever it is that he's espousing is just turning into disaster. And he, you know, just gobbles up everybody's money and energy doing that sort of thing.

So, at the time that Leary was—the way Leary got into the psychedelics was that psilocybin and LSD and mescaline were being dealt with on an experimental basis by psychiatrists, psychologists, physicians and all sorts of people; there were certain uses and purposes—it seemed to have some *real* function—you know, dealing with terminal cancer patients and so on and so forth.

Well, the justification for this kind of research and this kind of dealing with such a powerful substance has always traditionally—and seems to continue that way—it has to be done within a regulated and structured system based upon the structures that we currently have in our society—the ones that have been going on traditionally for ages. For one, it either has to be rationalized as a religious structure, or it has to be dealt with as a research tool, as a medical tool. But it was almost impossible to deal with something like this as "just something that people should do," you know. There was just no way to do it, especially back in the sixties.

So, there were people that were doing research, and they had committee meetings with the government, because the government regulates everything. First of all, you have to do politics. You have to use diplomacy, and you have to justify it according to the then-standard ex-

pectations of the society.

So Leary said, "Well, it all ought to be legal," and so on and so forth, "and we're going to work to do that." And the way he worked to do that was to go in and be fuckin' dingbat, you know, and say, "Hey, everybody ought to take it," and he started handing it out to everyone. And this made the people just freak out—they just panicked—you know, the people in authority—*including* the people that were in favor of research—they were *exceptionally* upset about all this sort of stuff. Sandoz Switzerland refused to continue to supply him any psilocybin for research purposes, and denounced him for his unethical actions. And he would do the sort of thing, like, he would get somebody who really was not *prepared* for this type of experience, and just dump a bunch of LSD or psilocybin in 'em, and tell 'em they're gonna have a good trip, and when they started freaking out he'd just walk out the door and leave the guy freaking out on the floor in this nice communal house that we were in...leave it to me and somebody else to try and *save* this person's sanity! [*laughs*]

You know, this kind of thing wasn't just a private matter; I mean, it was just absolutely clear the guy was unethical as far as the standards of the school and of research, etc. etc. And so finally, here was one espoused cause that he theoretically was in favor of, and within a very short period of time, after establishing himself in the media as the psychedelic clown authority and advocate, it all became illegal for anybody to touch it *anywhere*! It was illegal for anybody to do it for religious reasons; it was illegal for anybody to do research with it; it was illegal for anybody to use it for medical purposes; and it was gone and dead. And the only way you could use it was to become an outlaw and have to buy street crap and ultimately really get really fucked up. So, his main purpose was to make it outlawed!

When I was in Mexico, he said something, "Did you know that [Wilhelm] Reich died in jail?" And I said, "No, I didn't. That's interesting that you said that, because a

lot of people, particularly psychologists and psychiatrists, *deny* that he died in jail, because they feel so guilty about it." And he said, "Well, maybe they do. I don't know why they do that; it doesn't sound realistic to me." He said to me, "All great men" (this is one of his few philosophical statements that I'm sure is true), "All great men" (from his point of view) "are put in jail." And he said it in such a way that I immediately knew that he wanted to be put in jail. He wanted to be the guy that gets put in jail for some reason...that he can be the heroic, historical figure that he admires, like Reich and the rest of 'em. And sure enough, he managed to do it. And it was such an absurd, stupid kind of martyrdom—you know, the right for his daughter to go across the border with a roach stuck in her crotch.

V: [*laughs*] That's really what she was busted for?

BC: Well, yeah! He and his daughter and his son decided to go over to Mexico. Well, they went to the Mexican side and the Mexicans wouldn't have anything to do with them and sent 'em back to the United States. When they got back to the United States after being just fifteen yards on the other side of the border, they were coming in through customs, so they were searched. And his really dumb daughter, thinking that she really needed this roach—or, he said, "Hey, take the roach and stick it in your crotch; nobody will look there"—still had this roach stuck there, and they found it. And she was a minor, and he was bringing her into the country, and he was responsible. And he got self-righteous about this whole thing of being busted for marijuana. He was just so ridiculous; it was so shoddy and superficial.

He started defending himself as if it had never happened. I mean, it wasn't like saying, "Well, sure she has a joint, and everybody should!" He became this defendant in a legal case and he didn't *say* things like that. He had lawyers working, saying: "You can't search this, or that,"

dot dot dot—you know, all the legal precedents crap.

I don't know why you want to write about Mel Lyman.

V: Well, it just struck me as kind of a funny thing to do—

BC: I'm sure I gave him the idea that all you had to do to *be* God was to *say* you are. That's what I told him.

V: So, you were in Mexico after Newton—

BC: No, I was in Mexico before Newton. I was in San Francisco in the sixties; well, I came here in the fifties. I had been in New York, and met Leary in New York, and that must have been about 1959 or '60. And then I went to Mexico in '61, and one day he knocked on my doorbell and said, "Hey, it's Timothy Leary down here!" And he said he was going to go around to all these villages that were on the map for certain psychedelic mushrooms—not that they were traditionally places where you expected to find them, like Huautla de Jiménez, because the assumption was: wherever the mushrooms grew, there was a mushroom *culture*.

And so we went to a number of these villages, and he said he wanted to find out about the *use* of these things. Well, this is probably another of those instances of total defeat of his proposed...*goal*. We would go into a village; it would be all—almost all—Indian, or part-Indian. Sometimes there would be few people there that could even speak *Spanish*.

We could go in there; we would be these obvious, obnoxious, barbarian gringos coming in over the dirt roads into this adobe village with no electricity or anything like that. And the very first damn thing he does is say, "Where are the mushrooms? And where is the curandera?" And somebody would say, "Well, so-and-so..." and we might meet that person, and the first damn thing

that he would do, would say, "What happens when you take the mushrooms?"

I mean, can you *imagine* the kind of reaction these people would have, in a society where they are alien to the society... I mean, they are not a part of Mexico. The Indians are like the niggers of the United States in the 1930s. And the kind of oppression that's gone on over the centuries by the Catholic church against these kind of activities—you know, they burned and murdered people.... and, you know, all this sort of stuff.

Well, you know, you go into this village—first of all, that the people were even gonna *acknowledge* and talk to you, was such a great deal of generosity on their part, and a *danger* to them. And then you come in and you just— I mean, with no diplomacy, with no preparation, with no acknowledgment of *their* traditions or of their ways of dealing with communicating information, which you would expect a sociologist or an anthropologist, or anybody who was doing research like that... Leary comes on like, you know, the *Ugly American Tourist:* [*yells*] "Hey! You take mushrooms! What happens?" I mean...when he did this the first time, I couldn't believe it. The second time I *believed* it and couldn't understand *why* he was doing it. And then finally, after the fourth or fifth time, I realized that this was just an *aggression* on his part to force people into a point where nothing happened. I mean, they would clam up, right away.

I mean, here's this guy. They don't know whether this guy is an agent of the government; whether it's the narcotics guys that are gonna come down on this; they don't know whether he's associated with the Church—they don't know *who* this guy is and he comes on like this. And this seemed to be one of the main satisfactions that Leary had: was to go through a process whereby theoretically he's trying to achieve a certain end, and then he just turns off the whole thing entirely.

So, there was no research except in the sense of see-

ing how people react to it, and it was sort of like the most simple *level* of reactions! And of course most of that was what he exploited in the media, and on the public area it was like, you know, either you said, "Hey! Wow! Leary! Terrific! We're for ya! Let's smoke some more grass!" Or you said, "God, this guy's a threat to the society; he should be blown up, destroyed!"

V: Wait, did you ever go to the Huichol Indians? [who made "psychedelic" yarn paintings]

BC: No no, I saw them in Mexico City, but they were a long, long ways away; they weren't easy to reach.

V: Where were you living in Mexico at this time?

BC: Mexico City... Oh, Jean's gonna make me eat food now. Bye! [end]

BRUCE CONNER ON DUCHAMP [1979]

BC: Marcel Duchamp did some Rotoreliefs at one time that he tried to sell at some fair or exposition in Europe. Those are those things that go around and give the illusion of fishbowls and stuff, and nobody bought 'em. He was really disappointed because he thought this was going to be an obvious "big break" business ploy! And a lot of them, like, *disappeared*. Then in the sixties he discovered them some place, in a basement. And my dealer at the Alan Gallery in New York, Charles Alan, put on an exhibit of the Rotoreliefs and he sold them there.

I'd never met Marcel Duchamp but I suggested to Charles Alan that Marcel and I have a two-man show because at that time for about three years, I didn't sign

anything but I kept making all these pieces, right? And Marcel was into doing these things that he didn't make, that he *signed*, right? [*laughter*]

So what I wanted to do, and what I suggested to my dealer, was that we would close the gallery for a week and during that week I would totally repaint the gallery... the ceiling, the floor...except I would paint it exactly the same color and the same way it was *before*, so that when people came in, it would *look* the same...the walls would all be the same. And I wouldn't sign it. But then we'd take Marcel's stuff and put it on the walls or the sculpture stands. And Charles said, "That's a really good idea, why don't you suggest it to Marcel?" But I was terrified to talk to Marcel; I wanted *him* to be the intermediary...he wouldn't do it.

Then I was living in Massachusetts. A friend of mine was at Brandeis University and I called her up about one o'clock in the afternoon and said, "Oh, I'm going to go see Marcel Duchamp give a lecture tonight." I couldn't understand how Marcel Duchamp could be giving a lecture in Massachusetts and nobody that *I* knew knew he was doing it. So I thought it was a fraud...that it wasn't really going to happen. But I went out there.

But before I went out there, I took a case, like a glass case that I had gotten in Mexico. It was a little silver glass case with a hinge cover that one time I had a bunch of costume jewelry, beads, and stuff like pearls in, and now there were just like a few pearls stuck in it.

And when I didn't sign my own work and my dealer, Charles, wanted me to sign works, I borrowed a letter back from him that had my signature and then I had a rubber stamp made from the signature and I offered him my rubber stamp so that he could stamp all of my work. I said, "You can put it any place you want to." And I said, "Besides that, you can stamp the telephone posts, and you can stamp doors and other people's work, and your own letters—anything you want to." But he wouldn't do that

because he's *very difficult* in that respect. [*laughter*]

So after a while, I used it quite a few times. Then I put it in this little case and it sat in there; it was like one of those little relics—one of those Mexican relics, where the saint is laid out and you can see like a little bone or something.

And so I put a candle on top of it and it burned for a while and it sort of dribbled around. Then I had it sitting on top of a radiator and that winter the radiator got real hot and the candle went over the edge of it, sort of like a limp six-inch prick… You know… And it was like right over the opening of the box so you really couldn't open it without breaking the candle. So it just sort of sat around there for a long time.

And then when I heard that Marcel Duchamp was going to be there, I picked up a ball of string. I remember once he had organized a surrealist exhibit where he had run string all over the place.

Vale: 1942, Guggenheim Gallery.

BC: So I took this ball of string…and I also remember that piece that he did that was a ball of string—a cord—between two pieces of metal. I can't remember exactly what it was but it was a gift that I think he gave to Annenberg. [*sic*; probably Arensberg] And it was kept a real secret of what it was that was in there that made a noise.

A little digression: I was in an exhibition of collages and assemblages and that piece was in the exhibition; it was in New York. And while the guys were in the office, I unscrewed the top and looked in and found out *what it was*. I decided I would tell only one person and then I would not tell anybody any more. And I did. [*laughter*] But it's really easy. It's designed, really, to open up. It's so easy to open it up, that it's designed to look into it and find out what it was. But Annenberg never opened it up; he said it was still a mystery to him what it was.

So anyway, I went to the lecture and I didn't know

whether he was coming or not. I took that box with my signature. And the auditorium was full of people and he came in. He was introduced, and he talked about himself, and he had them turn the lights off, and he showed slides of his paintings that he'd done in the nineteenth century and on up to about 1910 or 1912. And he talked about them in like in the third person, as if he was giving a lecture on another artist. He would say, "Now notice the significance of the blue halo around the right hand"—and he wouldn't explain what the significance of the blue halo around the right hand *was*!

Then he had the lights turned on for about three minutes, and then he had them turned off again. Then started showing the slides of all the found objects and the pieces that he had done. Then after that they had a question-and-answer period. While this was going on I was wrapping the string around the box and the string fell out of my lap and went rolling under the chairs, and I kept on turning it, turning it until it *stopped*! I knew there was more string there and I didn't know whether it was caught on a chair or whether somebody had their foot on it. So I sort of pulled it a little bit...pulled it a little bit harder...and finally it broke! And so I wrapped it all up there, and I sat there with this thing on my lap during this period.

Then they had question-and-answer, and at one time one person said to Marcel Duchamp, "Mr. Duchamp, don't you think it's time that you *confessed*?" And he said, "Confessed *what*?" "Well, confessed what you've been *doing* all this time with all of these *things* that you make, and what you've been doing putting 'em in art museums and calling 'em ART." And Marcel Duchamp explained *exactly* what he was doing, which I've never heard anybody quote.

V: Hmm...

BC: But he said, **"I never called this 'art'. I never put**

**it in art museums." And, "They were all gifts. I nev-
er realized any money from them; they were gifts
of love to my friends."** It's a very unpopular phrase to
use…probably why nobody has used that phrase with
Marcel Duchamp, because they've invented this image of
him as, you know, decent. [*sic*] Nobody talks about these
things being gifts, or whether they were gifts of love, or
anything else. So the question-and-answer finished. Then
he was thanked for being there. And then obviously it
was what I knew would happen after that: this would be
the time when people would approach him.

So I *immediately* made my movement to the table
as Duchamp was arranging—ostensibly arranging his
slides, you know…little formal magic happening on his
table. And I came up and I had this box in my hand…and
all, you know, nervous and crazed at being here with the
superstar. [*laughter*] And I said. "Would you give this to
Charles Alan?" 'cause I realized after I'd brought it there
and I'd done all this thing I'd intended to give it to [Duch-
amp]…but I knew I *couldn't* give it to him because I didn't
know him! It wasn't *my* gift to him—it would've been an
obligation of some sort that I would be *imposing* on him.

I still wanted to do what I was going to do…but he had
to *participate*. So anyway I'd asked him if he would give it
to Charles Alan who we both knew and we both had this
sort of relationship as artists and also all the other stuff
that had happened. I held this out to him and he sort of
stepped back a little bit and he looked at it. He took out
his glasses and he very carefully looked at it from the sides
and from the top and then he said, "Uh, do you mean Dr.
Charles Alan of Madison Avenue?" (I don't know *where*
he got the *Doctor* Charles Alan) and I said, "Yes."

Then I started sort of *straightening up*—it was *inter-
rogation*; I had to give the right answers. And it was obvi-
ously very limited as to what I could say. He said, "What
is his number?" and I started running through all these
kabbalistic numbers, what he's asking for: is he asking

telephone number, what kind of number, what kind of magical number is he going to…? And I thought, "Oh god"; he said, "Madison Avenue." So in the most mechanical way I said, "7. 6. 6."

I'm holding this thing and Duchamp says, "I *will*," and on that "I will" I handed it to him…and he was *through* with me. I mean, I was *gone*, and this little bit of string just went through my hand as it went away. And I said, "Well, I'd certainly like to—I'd appreciate it if…" But I just didn't *exist*—he was now talking to someone else. But when he said, "*I will*," it was not just that "I will do this" but like he had *willed* everything to happen up to that point, and everything that was to follow. Like it was the whole concept of *will*. I imagine he had recognized what this box was in that short period of time.

And I didn't hear anything about it for about—I don't know how long it took. I probably should have kept dates, but it might've been a normal gestation period of nine months—who knows? But I got this phone call from Charles Alan in New York and he said, "I've got this *marvelous* thing that was given to me now. It was delivered to me and I'm *told* that it's a gift from *you*! Mrs. Marcel Duchamp came in here with it and, and she said that Marcel had just given it to her and told her it was *very important* and it had to be delivered *immediately* to Charles Alan." And I said, "Well, what does it look like?" and he described it, and he says, "It's really nice, and you know, Mrs. Duchamp is *really confused*—she doesn't know what was going on…why she had to deliver it *today*, you know? She said that about 10:30 this morning (the gallery opens at 11:00), Marcel said, "You have to take this *immediately* to Mr. Charles Alan, 766 Madison Avenue." And she came all the way over here on the subway to deliver it to me and you know, we're having the worst blizzard in New York we've had in years—I mean, the snow is already about a foot-and-a-half deep; the cars are stuck on the street, and it's absolutely the worst blizzard you've ever seen in

years, and she's all bundled up with all these—" [*laughs*] So like Marcel Duchamp at least waited until the most difficult moment to send his wife across town. So I think that's the sum of my Marcel Duchamp story…for *today*.

V: So who did you tell about what was in the box?

BC: Well, I think I had mentioned it to a couple of people, but nobody *really* asked—you know, *insisted* about *what was in the box*. I was at the Chicago Art Institute, showing my films for some students, and I think it was before or after some—oh, it was in between getting ready the equipment in the afternoon and doing the program later. I went to the cafeteria, being all nervous, and I sat down to have some coffee. I sat down and this one girl was sitting across from me. I started talking to her and I invited her to see my films and she said she was an art student. I told her my story about opening up the Marcel Duchamp *thing* and she said, "Oh, what was in it?" I said, "Well, I can't tell you." She says, [*emphatically*] "That's not fair!" [*laughs*] "You told that whole story—" and I said, "Well, if I tell you, I can't tell anybody else because I decided I'd only tell one person." She said, "Yeah." [*laughs*] So I told her. She took the whole thing on herself and carried it away somewhere else. I don't know; maybe I'll run into her.

BRUCE CONNER ON IMPERSONATION

BC: I ran into… I found out that Tommy Tadlock [musician-producer, RIP] was someone I met at the Rhode Island School of Design about 1963 or '64. I went over to his place and he was running his little light show machine and… And I guess he and his two or three friends were the only psychedelic dopers at Rhode Island School

of Design. I went there to show my films. After I left, I told the guy who invited me to tell people that I wasn't really Bruce Conner, that I had sent somebody else to impersonate me. So when Tommy—I talked to him about a couple of weeks ago—said, "Aren't you Bruce Conner, the filmmaker? I met this guy that was impersonating you [*laughs uproariously*] in 1963."

BRUCE CONNER ON "THE PRISONER"

BC: Now what time is it?

V: Uh, 10:53...

BC: Well, I think it's just about time to get over there... [to the Mabuhay Gardens, the Punk club in San Francisco]

V: You wanna see the Alley Cats, huh?

BC: Oh, certainly.

V: Hmmm...

BC: You'd rather watch television—

V: No.

BC: —and look at your Polaroid photographs—

V: No, not really... I would like to see "The Prisoner" because I've never seen "The Prisoner."

BC: Well, you'll never see it the way it should be seen now...

V: Why?

BC: You should've seen it on commercial television. Because what happened was, when the commercials came on, there wasn't any difference between "The Prisoner" and the rest of the television thing. It was like the commercials are all part of this diabolic *thing* that was happening…It was as though you were locked into this labyrinthine structure and the TV commercials just fit right *into* it. *Now*, what they do is, they put it on PBS and they have a bunch of dodos sitting around discussing it and analyzing it—

V: —afterwards. "The Prisoner," on Channel 9. It's that TV series—

BC: —starring Patrick McGoohan—

V: I never saw it until just now; that's why I'd like to see it every week.

BC: I only saw about three of them when it was going on 'cause I don't think I had a TV set at the time. But that's what it was like when I would see it, though. It would come on and then it would just totally alter your consciousness of television, so you'd get into this grotesque, surrealistic thing of who's number one and who's number two and obscure plots where you don't know who's causing what…and posters—all sorts of things that are caricatures of our twentieth-century of living… And then the commercials would come on and the people that were in them were just like these sort of robot-like number threes and number fours, talking about brushing their teeth and *happy* all the time…and *positive*, and announcements—everything was like that, even the breaks for the station, of whatever the network signs and everything…all looked like they were part of the same thing…and they would go

back into "The Prisoner" story. Now maybe people can get the same feeling about PBS but it'll be a little different. The last chapter is the most impressive one because it involves a distillation of scenes from all the stuff that had happened before or reenacted emblematic scenes, one after another, totally incoherent...

SCOTT SUMMERVILLE: I heard that it was incoherent because McGoohan, who besides being the star was also the producer of the show, had planned it for twenty-two episodes. And after episode number thirteen or fourteen, the British government informed them that their show was going to be cancelled. So he had to compress these final six episodes into like *two* episodes. So the last two episodes are, really, he took bits of scripts from the last *six* episodes—the scripts had already been written for twenty-two, and he had to jam parts of the final *six* down to two shows...

BC: It might have been a great improvement—we don't know. The cutting was very similar to, like, the commercial cutting in the last sequence, too. It was the one that most perfectly...because it was like—somehow it was like, just not only being the last program but also was like, it was like setting it all off into television *forever*. Like, that was the last program, and then they did the commercials and the titles, and the next program came off and it didn't wear off, you know—it *did* go on to the next situation comedy and all the other stuff. You know, at least when I see a really good movie, it's like you walk out and everything is like the movie is still going on! Or like: you *notice* things, like about color, or the way people move, or the way things take place.

I'm gonna leave so you guys can actually carry on the conversation—BYE! [end]

BRUCE CONNER ON RICHARD BRAUTIGAN & DEVO

[music playing loudly]
BC: ...Well it's just a bunch of a certain kind of inter-change where you expect: here's a buyer, here's a film-maker-artist, and we're talking about serious stuff, and then he [Richard Brautigan] comes to me and says, "God I couldn't sleep last night, I only got about three hours of sleep, I swallowed this pill, this pill, and this pill to go to sleep, and you know this morning, I got up and I couldn't do anything, and I've got diarrhea, I lost my sock," and it's like, I was his contact for just listing all the ills in his life. And then he would introduce me to people, which was marvelous, because he knew so many people there—

IVEY: Why did he pick Japan as a place to go to write?

BC: Because he's been doing it for like four or five years.

I: In Japan?

V: He had a Japanese wife.

BC: He went to Japan about five years ago and he's been doing it every year. And so what he does is—I mean, he can *afford* to do it now—he can live a third of his life in Montana, a third of his life in San Francisco, and a third in Tokyo...

V: He can wake up in the morning and decide to have breakfast the next day in Tokyo.

BC: Well, not quite—I mean, he's got his life more compli-cated than that. I mean, he's managed to subvert himself in certain ways. Like one thing that happened was: all

these books that he wrote started making a lot of money. And he lived for such a long time in the *same* apartment on Geary Street near Sears…

V: Yeah, I remember that. I went there once.

BC: For *years*! Even though his books were being published all over the place, he was still renting this seventy-five-dollar-a-month apartment—

V: Is that all it was?

BC: Yeah, but it was like: you turn on the hot water in the tub and it would take half an hour for the tub to fill up. And the people upstairs would stomp around and wake you—I mean it was really… But he didn't want to give it up. And then finally he *had* to, for some reason or another. And then he started sort of conspicuously consuming things. [*laughter*] But one of the things he thinks he's doing is that he—he's bought property like in Montana, and one of them is a nursery school for kids and another one is an old people's home—

V: Hmmm…

BC: And he says that he bought the places thinking he's taking care of both ends of 'em, right? And I said, "Look, Richard, you're being generous to them, but shit, you're still a fucking landlord! I mean, how can you *do* this? How can you be a landlord? I mean, you still got these bills and stuff and you know these people are still going to relate to you as a landlord…" So he's tied up a lot of his money that way. I think he manages to spend all of the money that he possibly can!

I: Did he have an original idea to work with, like in writing the script for the movie?

BC: I don't know that there's going to be a script. We only had one conversation.

I: Is that what you were supposed to do though? You were allegedly supposed to write a script, right?

BC: My idea was that we would go there and we would be forced to have to talk about the script. But we had one conversation about the script. He said, "When I first proposed the script, you were enthusiastic, then I saw you go through a period of apprehension, and now I see you in a state of stoic acceptance of this event, and I think that perhaps I won't really be able to write this until 1982."

And, you know, he has these plans. He has books and novels and everything planned out years in advance. And how much time he's gonna spend on this or that...

I: But what was his idea, though, for the script?

BC: He said it was based on an idea I gave him ten years ago: write a script for a movie and put in that movie everything that you would ever want to see in a movie! [*laughter*] So he said, "We're going to collaborate on a movie!" I said, "Okay, let's get together and talk about it." He says, "No, I want to write the script first!" That just puts me off until he writes the script.

So my idea was: through some kind of osmosis, by going to Tokyo for a month, we would invariably get into talking about things which would end up in the movie. I mean, he's kept things just totally secret from me. He said, "Well, when I come back in October, I'll write a script." Then he's decided to stay in Tokyo another couple months. Now he says it's 1982 and I say, "Well, okay." But I figured I had to start my movie by 1983. [*laughter*] 'Cause, you know, I'm gonna be fifty years old! And that's when I decided two years ago, "I'm gonna be fifty years old in 1983 and I haven't *made* (or attempted to make) that movie." I told him by *that* time it may be well in the works... [*laughter*] or maybe not; I seem to have retired

considerably from any kind of activity. [*laughter*]

You know, I go and absorb myself in other people's—you know, like I'm going to Los Angeles for the benefit of Friction, a non-band; I'm doing *that*—and I talk to myself, I mean: "Why the shit are you doing *this*?" [*laughter*] Because it's *easier* than if I work on *my own* stuff! 'Cause every time that I work on trying to promote my own stuff, I get enormously disappointed and upset and it costs me a lot of money and I'm ultimately not happy.

I think it's much better to promote these other people (and much easier). And then also, I don't have to worry about being a manager, because I won't do it, I won't do it. I mean, I tried doing things that seem like that and the first thing you do is: you make enemies. The second thing you do is: lose a lot of money.

So I figured I wouldn't lose any more money by just going and talking to people and doing everything *for free!* And maybe they'll just piss me off like Devo did (sooner or later). I mean, Devo, it's really tough; really tough. I had a movie I was gonna make with their music, and it took a year-and-a-half for me to get the music. And when I got it, you could put your hand close to it and you'd get pushed away real fast. [*laughs*] I don't think I'll ever do it. The movies are already finished in my head, and I have all the material a year-and-a-half ago. But I have such a terrible reaction now that I can't listen to Devo *at all*. The thing was, I called up Pink Section 'cause I wanted to show them that picture of them in the Japanese magazine, and *Marina* answered the phone. It's a picture out of *Slash*. They just picked a picture out of *Slash* and put it in there, 'cause they don't have any recordings or any direct connection other than…a lot of stuff that they lift out of other things. But Marina answered the phone and we had some real serious talks about Devo and such. And at one point I said, "Well, the thing about Devo is that they've just subverted themselves and gone over into the enemy's camp." And she says, "They haven't gone

into the enemy camp, they *are* the enemy!" [*laughter*]
That was so heavy I could hardly *deal* with that. I had to
change the subject right away!

Oh, they had a five-year, seven-year plan they used to
talk about: how they were gonna release these songs one
time or another. They didn't want to expose themselves
by doing shows in San Francisco because they would
wear out their *novelty*, etc., etc., etc.

V: Well, that's Jerry talking more than anyone—

BC: Yeah, but they all go together.

I: Recently I turned on the TV for the news and that show
Magazine was on. It's like a current magazine talk show
where they like bring up topics around the city. And they
say, "And one of our new currencies around the globe is
Punk Rock. And here's a tape of Devo, everybody's band!
It's going to take the Punk Rock Award!" or something
like that. And they had this videotape of Devo playing
and it was the same show I saw at the Mabuhay two-and-
a-half years ago.

BC: And they're all constipated and with back braces
and no freedom to move one way or another. They have
this illusion that they're taking over the whole business
whereas they're just *clones* of the system. Of course in
Japan, they're perfect—they love 'em. I went to this Japa-
nese bookstore and in front of the register they had all the
most popular magazines, and there was Devo in color on
the cover. Inside was about five pages of 'em. And then I
leaf through a bunch of other magazines—just what was
current, and I saw at least three other ones, that inside
they'd have two, three, four pages about Devo, with color
photos and stuff. Then I saw a place where there were
rehearsal halls and photographs of some people that were
doing their Devo—you know, they were being *imitated*.

One of those papers had a fake ad that they put together; it said "Pink Lady and Devo"—

V: It was a fake ad, huh?

BC: Yeah, fake ad. "Warner Brothers Presents Pink Lady and Devo" and they cut out this collage with Pink Lady fronting in front of Devo.

V: Aren't they doing disco: Pink Lady?

BC: They're a pop duo, only they're losing power. They're not as strong as they used to be.

V: Hmm...

BC: But you know, they do cover things of American songs and stuff—they have no real identity. [*to Ivey*] Are you going somewhere?

I: I'm going to the Mabuhay. Wanna come?

BC: Mm hmm. I gotta do *something*. I didn't get out of bed until like 7:00.

I: C'mon, Vale! Let's go!

V: Okay.

BC: I'll carry my suitcase...

BRUCE CONNER ON PUNK MUSICIANS

BC: Country music: I mean, it's disgusting! You hate it most of the time, but every once in a while... First of all,

it's the only music you can hear that deals with songs about poor people—

V: Exactly! Exactly.

BC: —and asks questions like… No matter *what* anyone says about Johnny Paycheck, when he says, "Take this job and shove it," I mean, for *me*, that is heavier than the Dils doing "Mr. Big"! [*laughs*] "Hey Mr. Big, driving in your big Cadillac down the street, and I don't have a Cadillac to drive, I gotta take the old bus." I mean, it makes—it makes the Dils look really stupid—

V: Well, they're young, you know—

BC: Well, that's a good excuse.

V: Yeah, well it has some validity… Well, you know, one of the girls that lived with them for a while told me that their parents pay both their rents and always have…

BC: Yeah, they're just high school, college students, that's all. You know, like, the whole music scene is made up of people—like the whole art scene—it's made up of people that have—mostly—some kind of independent income. Usually, they come out of a higher-middle-class or middle-class background where they're *subsidized*, because really, they're reflecting—

V: Even if they're subsidized by SSI?

BC: I mean, they're *rare* people. I mean, they're *rare* people, I mean, like… I always liked Negative Trend so much because they *really were* fuckin' living off of food stamps; they had a dollar and a quarter in their pocket and they're still that way and they're still going on and Dee Dee is—I

mean, fucked-up, crazy, but—she always says terrible things, she rips off people [allegedly—*ed.*] and she does terrible things, but I mean, nobody's taking care of *her* except *herself*—

V: Exactly. And that's why we can never get a hold of her.

BC: Yeah! Why? Why *should* we? [*laughs*]

V: No, but I mean...

BC: I mean she'll get a hold of us when she needs to. [*laughter*]

V: Right.

BC: I mean, that's really dependence—

V: What?

BC: That's really dependence. I mean, she's... So many people that I see in the scene are like, dependent on *other* people or dependent on some kind of concept that they're going to have ultimate power through media. And the people that I like so much are the people that are so personally involved that anything that doesn't fit, just doesn't fit. I don't think Dee Dee compromises *too much*... Just a little bit! [*laughs*]

V: Right on...

BC: Yeah.

V: I loved talking to her the last time she was here; it was a real kind of "pure" experience—

BC: You know I have some heroes now that—

V: Really? Who?

BC: Well, I don't know. I like David Thomas [Pere Ubu vocalist] an awful lot. I think he's really—

V: You know that I have it on tape, him trying to proselytize me—I want to print it in a book—to become a Jehovah's Witness. He was sincere.

BC: Really? He was? He was doing that?

V: Because he trusted me *in a way*, you know, enough to open up...

BC: Well...

V: But it really kind of disgusted me... *Jeez*...

BC: Well, just because he's crazy that way... Why print it?

V: Well, I'll tell you the truth: I have been debating it 'cause I don't like to print stuff that... I like to print suggestions and ideas and catalytic-type stuff so other people go off and *do* something––

BC: See, I've met so many people that are *so* intelligent and they have so much to say and they have a structure that they're basing it on...like some kind of established social/political structure or religious structure...which has *absolutely nothing* really to do with *what they're saying*—

V: Yeah! Well, that's the problem!

BC: Okay, but that's the thing, is, that: many times the people that I find that have something to say have a struc-

ture somewhere, like, you know, like you're talking about Thomas and Jehovah's Witness… That is so fucked-up that you can't conceive of how they could be serious about *anything*. But I don't know why it happens, but it invariably happens. I find that in most—

V: I mean, I hate all organized religions—

BC: Yeah! But he's not organized fucking religion. Can you imagine him walking into a Seventh-day Adventist place and—I can't. I can't. I mean, he must have such an esoteric view of Jehovah's Witness [*sic*]—I mean, there's *no relationship*. I think of him as being a super intellectual who has elaborated such a fantastic structure on this very—what we see is *very superficial*. I mean, his view of it is probably so extravagant that it has absolutely… I mean they wouldn't even *recognize* it if they walked into a meeting and you started talking to them. I don't know. All of those social religious political structures: I don't think they have a hell of a lot of meaning, as far as anybody dealing with other people. [*walks away*]

❊ ❊ ❊

BC: What do you think you have on that?

V: Who knows… I have about a half hour, judging by the tape.

BC: What difference does it make?

V: Uh, cosmically I agree with you but you know I still have an answering machine tape from you in which you're leaving a message on giving me an updated instruction on preserving the *Search & Destroy* flats. [*laughs*] You know, like removing the glue from the back of the stats…

BC: A simple, practical process...

V: Right... Which I never *did* by the way, but they still look good—that means they'll still reproduce if the occasion ever arises, which I'm not counting on...

You went to Japan; what do you think the difference between Japan and China is? Here in Chinatown people bump into me if I don't step out of the way. And that sounds really the opposite from Japan—

BC: I didn't talk about Chinese at all much with anybody from Japan. And when I did: [*sotto voce*] "Chinese are crazy." [*laughs*]

V: I don't drive much, but I've heard people complain about Chinatown drivers who've moved here from Hong Kong: they'll stop suddenly; go down the wrong side of the street—well, in Hong Kong, *everyone* drives on the "wrong" side of the street; the British system. Maybe it's like they feel they're the only person in the universe—

BC: Yup. They're all living inside of a very tiny space.

V: Well, for one thing, China has all that huge land mass—

BC: But they don't know it. Chinese are totally lost in China. They don't know it. They have no concept, as far as I can see, what that land mass is. Somehow all of that political structure of "This is China, and somebody's in charge"—all they do is try to *adapt* themselves in whatever way they can, to whoever's telling 'em what they have to do.

V: I remember several years ago reading in the paper about all these young rebel Chinese kids who would

do little petty crimes and listen to rock 'n' roll—like about 60,000 of 'em...in Red China. And they refused to work...

BC: Sounds like something that didn't exist very long.

V: Yeah, because I only read about it once.

BC: They were taken out into the fields, just like the landlords...just a mile out of town: "Let's go for a walk outside of town."

V: Oh. You think they were "done in"?

BC: Yeah. They don't tell you anything.

BRUCE CONNER ON JAPAN

BC: First of all, I think of myself—and I think I'm different from many people who come out of Western society and go to Japan—I think of myself as *an enormous intruder*...that I am the *wrong person* to be there. I have nothing to do with any of their life. I'm too big. I'm too clumsy. I don't talk Japanese. The Japanese society even excludes people who are Japanese that marry people that are not Japanese or live in Hawaii... They don't consider people who live in Hawaii that are Japanese as being *Japanese*. It's some kind of mystical thing that they have. Many of the artists, sometimes, I find, what they're trying to do is to understand themselves as Japanese...that somehow they've *lost* the concept of what "Japanese" represents. And they're trying to find out *what it is*. And in different areas of things that I would understand that they—

V: Tadanori Yokoo: that's what I thought when I looked at his work. That makes sense. And he's even kind of successful.

BC: See, these enormous changes have taken place in, like, a hundred years...which are comparable to like 600 years of Western civilization; they've all taken place like in a hundred years. And most of it's only taken place in the last thirty.

V: After World War II—

BC: Just *total disintegration of all the structures.* First of all, it was a society where Hirohito is the "God-Emperor." And everyone believed they would never lose any war. They were behind the God-Emperor; they would always succeed. When the God-Emperor said, "Surrender," that was like a *concept* that had never existed: *to surrender... and continue to live, after that.* You know: the harakiri, the whole destruction. Once you fail, you fail totally, and you destroy yourself. And for the Emperor to say, "Surrender, we've lost the war," and for the Emperor to continue to *exist...* I think *that* was the most shocking thing: that Emperor Hirohito did not kill himself. This guy's still alive!

V: He is? Wow!

BC: Yes! Emperor Hirohito; he was here at the end of the Second World War. I saw him drive down near Japan Center. He came here to the United States, and one day I was driving down Geary Street and I saw all these hundreds of people with little Japanese flags—I knew the Emperor was in town. And I parked and I went out there and it was me and maybe a dozen other Americans and *thousands* of Japanese, all over the place. And this limousine came down; in the back seat was supposed to be Hirohito. But you didn't see him; he didn't gesture; he didn't move.

And there were these guys up on the top of the roof—you know, Americans with their submachine guns and stuff. It was a terrible, frightening experience for *me*, because I felt that any kind of unnecessary gesture that I might make, might be interpreted by these people as being *aggressive*. But for me it was an accident. It was a happen-chance that I realized this was happening; that this was the largest Japanese community in the United States and the Emperor of Japan was driving through it. [*laughs*] It was such a weird experience.

The feeling that I got similar to that was: I was in Tokyo. And I had this map of Tokyo, and I knew where I was. And I looked at this map and I saw all these green places that represented parks. And I went to this one park and it was the Meiji Jingu Shrine based on the Meiji empire which was previous to Hirohito. They had this park and these buildings they'd reconstructed since the Second World War. And there was another place which was like an arboretum that I walked through in the middle of Tokyo and saw only about seven or eight people—it was *totally isolated* in the middle of Tokyo!

And then I looked at the map and there was another place that was all green; it happens to be a political enclave. They have a building that's very European and the Prince (I guess the child of Hirohito) *lives* there. Well, I walked out there thinking that this was another park, looking for the entrance. And as I walked around this place (walking around it must have been two-and-a-half miles) every entrance that I'd go by had most-forbidding army guys standing out there with their guns and their shields and stuff. This is like the third day that I tried to explore Japan in the rain—it rained for twenty-five days, and that was the last day I tried it. I walked around that place and I would go up and I finally would ask somebody, "Could I come in here? Is this a public area?" "NO! Private." But I was aware of it very... [*laughs suddenly*] I was walking around there and I thought, "Well, perhaps there

is some place that you can go in a gate…a place you can walk into," and it wasn't.

V: But they didn't kick you out?

BC: Well, I never went IN. But that was the place where I saw a van, like a bus, with chain-link-facing over the windows. And it was full of army people with guns. And there was one man out in front who had a shield with a baton. And there was also like a…something that you could put out in front of a roadway so that if you tried to drive through, you couldn't drive through; it was like a blockade sort of thing. And that was when I locked my-self in my hotel for two days! [*laughs*]

V: Wait; I don't understand; why?

BC: Well, like I was walking out, and going everywhere… and all the parks…and I interpreted *this* place as being a park, right? And it was raining like crazy. I was walking out in the rain. In spite of the rain I would find places that I really enjoyed being into, and I spent a whole day, prac-tically, walking around this place and then finally coming back on the subway, soaking wet, and all the people I had talked to were people that were designed to *fight*, and at-tack someone else…and I *regressed* for a couple of days! I had all these canned foods and stuff in my room and I put a sign on my front door that said, "Do Not Disturb," and I hid out.

But the most confrontive [*sic*] kind of situation was coming into the *airport*, Narita Airport. When we arrived and we came out of the airport—you know there's been enormous confrontations about the peasants, the farmers who had the land that was built upon, and it's going on. There are leftists who, two weeks before I left, there were some people (twenty or thirty guys) that attacked a train going to the airport containing fuel for the airlines, and

they forced the engineer and his assistant out of the train, stopped the train, set fire to the locomotive... But they didn't blow up all of the rest of the stuff; somehow they managed to do that without injuring the other people. But when we got off the airplane, there's this corridor; there are checkpoints. And I saw like fifteen trucks (like the one that I mentioned that was there by that place) obviously full of soldiers *just waiting*, twenty-four hours a day. They must have like 500, 600 people there at all times to protect that airport.

V: That many?

BC: Yeah, it's awful. Like when I left, I went to an air terminal in Tokyo. Before I got on the bus, they body-searched me—more than they would *here*. I got on the bus, I went to the Tokyo Narita Airport, they did the same thing at the airport. It was like somehow they would even suspect that between the time that you got on the bus, and when you got into the airport—

V: —you magically could produce a bomb or—

BC: *Yeah*; something like that! It was really grotesque. But the thing is that the airport interfered on a tradition of Japanese society where the people that had the farms— their families had been there for 400, 500, 600 years—always farming the same place, and then they impose this "eminent domain" procedure (which we're familiar with here) onto those people. And they were "we'll take you over here and put you on this other place," but it didn't *mean* that, because the *land* that they had been on meant so *much* to them. And there were continuous attacks on that airport forever and ever. Yeah, they had some really marvelous things happen two years ago where they tunneled from half-a-mile underground to the control tower. And they'd worked it out so perfectly. I mean the people

that had done it had done it underground, secretly. They'd done it so perfectly; they even had washing machines, dryers, and bunks so that in this tunnel they could sleep in the bunks and then they could put their clothes in the laundry and wash 'em out— [*laughs*]

V: That's another thing; Japanese are the cleanest people in the world with that population density—

BC: So then they coincided their exit out of this tunnel to coincide with ten thousand people performing a demonstration and attack on the fences to distract everything. And they came out of this tunnel, went into the control tower, and whereas they could have used explosives and such, *manually* they destroyed things. And they didn't hurt anybody. I mean it's like: one of the amazing things is like these kind of confrontations where they respect each other... (Over there on the lines though, I'm sure there was a lot of [*laughs*] head-cracking and stuff.) But the people who *planned* this operation really did not plan to hurt another Japanese. They planned to do it and destroy the machinery, and they did it manually—they did it with sledge hammers... And it took 'em six months to repair all this stuff.

So I kept thinking when I was flying in, "Maybe they'll wipe us out as we land." They only have one airfield, one landing strip; there is no other. So all the airlines land on one landing strip. And I kept thinking about this experience of being totally in sympathy with these people, but at the same time being blasted out of the air and destroyed because I was in the fucking airplane.

V: But they wouldn't do that, though—

BC: Well, it might; who knows?

V: What you just said contradicts what you said

before—

BC: But, it *could* get out of hand. It could get out of hand.

V: I guess there could be one "crazy," even in Japan.

BC: But basically all the confrontations *were* destructive confrontations; it was just that they *happened* not to actually destroy. The people would try to build, physically, towers on land which was not airport land…to build the towers so high that the airlines would have to run into it—that was before this other thing that they did. And then the army would go in and destroy the towers and stuff like that.

Now they have a compromise, because they're building another strip, and I don't think they've dealt with what they had originally. But how they're dealing with it is the most absurd kind of bureaucratic "solution." They're going to build another airstrip. And on the land that has been traditionally there for hundreds of years, they will remove ten feet of earth. And when the person whose land was there has moved to another place, they will move that ten feet of earth into the other location, and that is the compromise: *they have their traditional land…which they have decided is ten feet deep.* [*laughs*] Right? And they will accept that. I don't know what would happen if the ten feet of one parcel gets mixed up with the ten feet of another parcel… They would have some terrible psychic problems!

V: Amazing. There's some real principles in action.

BC: **One thing about Tokyo is:** *everything's on time.* My program at Image Forum was scheduled for five o'clock, and another program at seven o'clock. I said, "Well, maybe some people will be late." *NO! Five o'clock.* It's like the subway: there are about seven or eight subway lines. They

connect one with another, and each line has a schedule. And when they stop, they stop for only a certain amount of time, and the doors close. And then they go on, because three minutes later there's gonna be another train there. They can't stop and wait for anything. So what I thought when I heard about people pushing customers into the train was that it was some kind of really barbaric thing that was happening. But basically what they're doing is making sure that everybody is in the car before the doors close. Because the doors are gonna close, and if they're stuck in between the doors, the doors are gonna close and they're gonna have legs or arms sticking out [*laughs*] *no matter what*, because three minutes later another train is gonna be there. *That's* the way BART should have been; that's what they promised us!

V: Good; you've just demystified that for me. Because that always bothered me when I read about it.

BC: That's what they always promised from the very beginning: that we're gonna have this totally automated train system with trains like three minutes between one another; they would happen so often that nobody would ever have to stand up; they would always sit down. They even designed these cars so that there weren't any railings to hold on to. And then General Motors and all the other people that were supplying the cars *lied* to them. They said, "This is the way it's gonna happen."

V: I don't know about you, but I need to eat something. [*points to toaster*]

BC: I'll have a piece of toast. I don't eat butter; it makes me sick. I got an ulcer ten years ago.

V: Ten years ago? They finally abandoned that milk cure for ulcers. Want some jam—look, no sugar!

[Bruce brings up *Sluggo* magazine]

V: The *Sluggo* people in Austin had a printing press. But it was so heavy they had to leave it behind. Nice people. They moved here—even stayed *here* for awhile.

BRUCE CONNER ON PUNK IN 1979

V: Hey Bruce, how are you?

BC: Being held hostage.

V: Oh, yeah. They seem to have stopped for a while, those noises, but we're not sure. Ruby's still monitoring them. So, how was it?

BC: Which one?

V: Which one what?

BC: Was it?

V: Anything. [*laughs*]

BC: [*laughs*] Ah ha ha ha, ha ha ha. I may have a tape machine around to do laugh tracks or something.

V: [*laughs*]

BC: Are you gonna ask me obscure things like that?

V: No, I'll ask you something specific... No, I won't, actually. Hey, did you enjoy yourself Saturday night?

BC: I don't know if I did or not.

V: Yeah, it was so weird, wasn't it?

BC: Well…

V: It was like nostalgia and anti-nostalgia simultaneously.

BC: Mm hmm.

V: Because, I thought, it looked to me like there was friction between the Sleepers, and it looked to me like—and UXA just didn't sound real good.

BC: It's later, it's later. They broke up for a *good* reason.

V: Oh yeah?

BC: Well, there must be a good reason, because they were so hot when they were doing what they were doing.

V: Yeah, the guitar tone didn't sound as good.

BC: Yeah.

V: It sounded kind of, I don't know…in and out, and over-something…over-treble-ized.

BC: Mm hmm. Well, I'm beginning to research other areas myself.

V: Oh yeah? Such is what?

BC: Well, I've been looking for honky-tonk. I found myself going into a liquor store with a couple of down-and-out alcoholics on Sixth Street, about two weeks ago…

I don't think we ought to deal with this at all, except when it *means* something. I mean, we have our friends. You know, I thought we were dealing with our friends on Saturday night.

V: Yeah. What, you mean you didn't think that after it?

BC: Oh yeah, I did. But, you know, I wasn't really *disturbed* about it; I was disappointed in certain ways.

V: Oh yeah?

BC: But you know I thought that was what the evening was anyway; it was like it was predisposed to be disappointing.

V: Yeah, that's what I thought too. Although I didn't actually think it quite like that. Well for one thing, I thought that the Sleepers might sound—I don't know, *different* than they did, somehow.

BC: Well, I still think Ricky [Williams] is the same person that is really there; I *love* Ricky. And I think Dee Dee [Semrau] is too. And the other guys in UXA were there, too—they're in a *different place*, they're just not there.

V: Yeah.

BC: They're just not there together with Dee Dee—I don't know *why*, but they're not. And I *know* why the rest of Sleepers isn't there.

V: Oh, why? Why do you think?

BC: Well, I think it's very simplistic: the ego problems. Concepts of artistic control, stuff like that. That's more common, in bands at least. But I still think it's stupid.

V: [*laughs*]

BC: They really had a lot fucking conflicts; and it was obvious, but I kept hoping that that they would get over 'em. But, what do you do with *Ricky*? I mean Ricky has to be taken care of. He has to have people just as far on the other side as possible.

V: He's been away; that's why he's been cleaned up a little. He hasn't been around the Punk scene.

BC: Well, I don't know that he's cleaned up that much at all, I don't know.

V: Yeah well, probably he's cleaned up enough to actually show up and play.

BC: When did he get cleaned up, when did he clean up?

V: I don't know, that's what I heard: he's been laying low and cleaning up.

BC: Well, I don't know; two months ago I saw him and he had this bandage on his wrist. Then he said, "I've been in the General Hospital." I said, "What were you there for?" "I can't tell you, you'll just tell everybody."

V: [*laughs*]

BC: Well those are the people that clean him up. They're gonna flush out his body and flush out his veins. The amazing thing is that he ever got involved in Flipper. Because everyone there was so, you know, going off into random directions, into chaos, and that's the direction that he goes into, and he needs somebody to pull him back together again. One time I saw him at Loma Linda and—

V: I thought that worked.

BC: And—what happened—he took over somebody's guitar. I can't remember what happened.

V: I don't remember that.

BC: Yeah, it was like something happened. Oh, I remember; Will [Shatter] was bleeding. Will was bleeding, and he didn't realize he was bleeding, and he left the stage, and while he was running around, trying to cope with all this thing that he didn't know what he was doing, Ricky took over the bass. He straightened up. Before that moment, he was like just the personification of eccentricity. And he was inside-out, and all-around, up-and-down, everywhere that you could imagine him, nowhere. And then he played this bass, and he just straightened up—*physically*, he straightened up; *vocally*, he straightened up. And he started doing the structure that he's been playing off of. You know? I think he's a marvelous artist. I love him. I just love him.

V: Yeah, I like 'em both. Yeah, those of course are the favorites, out of those bands.

BC: But it's really getting down for me, like, individual people and not bands anymore.

V: Huh. Well I like Bob [band]—did you ever see them?

BC: No.

V: Oh, you should go see them.

BC: I heard about 'em—

V: I like at least two people in that band.

BC: What about Humans?

V: Never saw 'em!

BC: Oh I saw 'em.

V: Are they any good?

BC: Well, they really are eccentric. But, you know, the times that I've seen bands that have been extremely eccentric, they appear to be so weird and so many things going in so many directions, a lot of times it just looks like a malformed band—I don't know. But I think that's what I like, that's what I like. I can remember lyrics, actually, from the Humans, when I saw them the last time. One song I remembered was—there was a chorus, "I stole your Benzedrine; I stole your diamond ring; I stole the wristwatch off your hand." That was the chorus. And they looked and acted totally atypical. They weren't a Punk band, they weren't anything. And some of the bands that I really like are like that. Eye Protection—I don't know what they're like now... But they're just like four or five people that you can't believe that they can be in the same band together. I mean, you can believe that some of the old-timers all get together in one band, and they all play together, but...

V: What did you think of SSI? You saw them. But they didn't sound very good, though, when you saw them.

BC: When did I see them?

V: 330 Grove? With the girl bass player, the black girl?

BC: Oh I *liked* 'em.

V: I liked them too; they played tonight.

BC: Yeah, I think they're really—I like them a lot.

V: Yeah me too. I just missed 'em, tonight. They played at 9:45.

BC: Where were they playing?

V: At the Mabuhay.

BC: 9:45?

V: Yeah, it's a benefit tonight for KPFA.

BC: Oh, well that's why I didn't go; I didn't want to support KPFA; I think they're total assholes. And after all the fucking work that anybody did, you know—[tape skips]

V: [*coughs*] Ugh, I still have my illness.

BC: What do you have there?

V: I've been in bed all week!

BC: What have you got?

V: I don't know. Well, I'm getting better.

BC: You go to the doctor?

V: Nah, I don't believe in that.

BC: You don't believe in doctors?

V: Well, not unless you're really extremely ill. I'm getting well.

BC: Well if I'm sick for a week, I think that's extremely ill—

V: Well not a week, Tuesday. Monday night on. Tuesday morning.

BC: You're rationalizing this because you don't want to go see a doctor, that's what. I can tell right away.

V: I'm almost well.

BC: Huh?

V: I'm almost well.

BC: You're almost well? Come on, try to speak clearly despite the fact that you're racking with pain, and—

V: No, I have no more—no, it's just a cold now, really, I'm fine. [*laughs*] I mean I was okay, I even went Saturday night, to that.

BC: Did you stay? How late did you stay? Because I keep losing people at the Mabuhay.

V: I was there the whole bloody time! Until there were just a few people left in the place, and I didn't even see you, at the end. There weren't very many people there at the end. I mean, you know, after they marched 'em out, most of them. You must have left early.

BC: No, I left after the last song of the Sleepers. Yeah, I was there. But I didn't see any reason to stay around. I mean I've *done* that. I've stuck around till 2:30 in the

morning.

V: Yeah, yeah, right.

BC: And I've gotta figure out whether I'm gonna do that or not.

V: I went to Target Video on Van Ness afterwards, but it was just the same old thing, you know. Same tape even. [*laughs*] Talked to a few people and then finally left. It was nice to leave. Believe me, I was pretty tired. Yeah, there were a lot of people there, that wouldn't ordinarily go. But there were still like the Saturday Night Special types there. Tourists, yelling out their inanities.

BC: Well, the old crowd wasn't really there either.

V: Yeah, that's the way I saw it. The old crowd wasn't really there—

BC: Nope. They weren't here for the nostalgia. I don't know where they are. They're probably insurance adjusters and stuff—

V: Oh god... [*laughs*]

BC: Did you ever meet Trixie?

V: Yeah, I think so.

BC: She came up here and she was crazy about Crime?

V: Oh, Trixie! Yeah, of course, Trixie. Whatever happened to her?

BC: I don't know, I was talking to Hank today, and I said,

"What happened to Trixie?" And he said, "I think she took the vow; she's a nun."

V: Oh I don't believe that.

BC: I don't believe it either, but—

V: That's a crock of shit; I think she's living in New York City, the last I heard.

BC: Yeah, well that's what he said. That's what I heard too.

V: From Hank Rank? Well, how would he know?

BC: They know more about Trixie than anybody I know of, because she was crazy about 'em.

V: I don't believe that.

BC: Okay, I'll ask Hank where he got his information.

V: Yeah, you ought to.

BC: I think it's quite possible.

V: I think it's too soon for people to be doing that kind of thing. Although I—

BC: It is poetic.

V: Yeah, I suppose. Somehow it seems like I've heard that one before, if you know what I mean.

BC: No, I haven't heard it recently, in the last two years—

V: No, not in this context, but I mean, it's bound to happen. I mean, you know like Punk girls are work-

ing as topless dancers now and looking sort of more like Vegas showgirl hairstyles.

BC: Somehow they've been failed. We haven't done it for them.

V: Yeah, there's several that are doing that. It always happens, they don't do it at first but after a while they do it. You know, they say, "Well, it's quick money, you know, they'll hire me." Well that's actually what Joey [Swails]'s girlfriend is doing. You know, Joey in Crime, Cathy.

BC: Well he's working as a disc jockey in one of those places, too.

V: Oh, I thought he was just fixing equipment.

BC: No, he's running records at some topless place; maybe his girlfriend is working there, and he's keeping close.

V: Oh, well that could be, yeah. Well once you get plugged into the strip, as they call it, you find out all the jobs that become available *when* they become available, so the same girls work different clubs, you know, and trade off, and all that.

BC: Well you know one of the processes of examination of what is taking place is in reverse. You find out where people go, and what they end up doing, and then you try to determine what it is that [tape skips]. Something starts out with a premise, and then—

V: Yeah. A premise?

BC: And where does the premise end up? I mean there's a bunch of Dils, with a premise, that they exploit.

And then it becomes, to me, you know, looking from the outside, that that's all they're doing, is *exploiting*. And they say, "Boycott the Mabuhay, they're charging more than three bucks!" I mean, that kind of short-term exploitation represents the total negation of the whole social milieu that they've been involved in. Because obviously, if you know like two months later they're gonna be playing for a crowd that's more than that, they've gotta rationalize it.

V: 650, Berkeley, 750, right.

BC: And when they rationalize it, they've lost the hardcore. They don't have any hardcore. They *looked* like they were hardcore, for a while.

V: Yeah.

BC: But in a way I think they maybe represent a really classic dramatization for other people. The ones that go 'round with their little red books. [*Quotations from Chairman Mao Tse-tung*] They *parrot* what's there. I mean, they're going to do something else, because they can't cope with it. At least at our place.

V: Wait, *who's* gonna do something else? Oh, you mean the people who like the Dils?

BC: The people that parrot the—

V: The Dils.

BC: Well no, that parrot the little red book.

V: Oh. [*laughs*]

BC: They're parrots, they're parrots; they gotta give up!

Some time or another. And I'm not sure whether the Dils have given an exemplary demonstration of behavior that other people should follow, or not. I can't make judgments about it that way. Because I feel that, you know, they've acted out a whole series of commitments that people have been going through, and, you know just like you say, you know like somebody's there, and then pretty soon they're out on the strip being topless dancers or whatever.

V: Yeah. Sort of defusing their social rebelliousness.

BC: Well, was their social rebelliousness fused in the first place? Was it burning? I mean, were they gonna blow up, were they gonna *do* anything? I don't have any specific red resistance but I do remember people that would have a hammer and sickle on one side and a swastika on the other.

V: [*laughs*] Offend everybody.

BC: And, you know, when you have a diametrical opposition like that, somebody's gonna do the other side of it. You always think of things as being classically a balance scale, no matter what you do. It's going to include elements of the other side of the balance. And once the balance goes all the way down, that's the end of the balance, but it still represents that there's an *opposition*, which is the split in allegiance. There's a split of allegiance. You know, everybody I know is involved in a split of allegiance. And what I'm interested in is how they deal with it, how they make their choices, and the closer they keep to the center of the balance. Am I getting too extreme here?

V: No! This is exactly the main problem that's been bothering me. Trying to figure it out, that is.

BC: Well, I think we're in an entertainment industry, Vale.

V: [*laughs*] All art is...I guess.

BC: And I think there is an audience for artists, and there is an audience for public events, which are made up of people who have experienced this kind of thing, for a period of time. Like I went to see Bob Dylan, two or three weeks ago. I was *not* disappointed. I had reservations, I did not like certain things, and unlike Joel Selvin [*San Francisco Chronicle* music critic] I was not there under false pretenses. I didn't expect him to be an entertainer; I didn't expect him to play me things later—you know, some of his old songs; I didn't expect him to tap-dance for me. All I thought I was going to was I was gonna see Bob Dylan. And I *did* see Bob Dylan. [*pause*] And I just don't know how many people there are, that have been in the business of being onstage and in front of a public for twenty years or thirty years that goes [*sic*] on stage and performs nothing but new songs that they have written. I mean, *who* do you know that's done that?

V: I can't think of—

BC: Ray Charles, have you seen Johnny Cash do it? Have you seen—

V: [*laughs*] "Ring of Fire."

BC: Have you seen—I mean Talking Heads don't even produce—you know, they don't go onstage and do nothing but new songs. You know, they do some old songs, they do some new songs.

V: Yeah, they do their greatest hits, alright.

BC: They all the fuck do that! You know?

V: Yeah.

BC: And here people are totally pissed off at Bob Dylan because he's coming out there and doing something that they never expected. That's mostly what they're pissed off about. You know. All the valuations that they make about, you know, "This is righteous—"

V: Religion.

BC: And I saw this show, and I didn't see it at all, I saw it totally different. What I saw was this guy that's been on the stage, he's been doing this stuff for years, and he's still on the edge. I still have this feeling like—he's in the total center of chaos, and it's like some kind of triumph of his own consciousness that he can stand there on the stage and *do* this thing. And I didn't think he was trying to convert anybody; I thought he was trying to convert *himself*. That the event that was going on was not Evangelistic Born-Again Christianism. It was Bob Dylan trying to pull himself together, and maybe not succeeding, night after night. I had a feeling that he was extremely desperate. *Not* secure.

V: Desperate for what? Or just—

BC: Well, *something to hold on to*. And that's what I see all that—a lot of that, you know, Christian music is—is really hard-core, desperate music. I think that's what Hank Williams did, I think that's what a lot of the rock 'n' rollers—I mean that's what Little Richard does!

V: Right.

BC: I mean the guy on the—there are people that I see as supreme existentialists. That's an old fucking word, right? And all you have to see is that they survive time after time, and they go through the most extreme transformations; some of them do 'em, you know, very publicly.

And I think that *they* succeeded; like most of the rock 'n' roll thing and most of the church music and everything else that's coming out of Gospel, is so mixed up. And when you hear the Staple Singers singing their songs, and there's the little baby daughter singing, "Daddy, Daddy, Daddy," talking about, theoretically, God, but Daddy's over there playing the bass guitar, standing onstage with her. It ends up being an affirmation of power or dedication or, I don't know what. You know? I think that most of the experiences I've had out of the Mabuhay here are closer to going into holy roller churches. Or the Avalon Ballroom [in the sixties].

V: Yeah, the good old trance state. Yearning for, at least.

BC: No, that's not—that's too simple.

V: No, I think people want—they'd like to approach something like that. People need it.

BC: Well, it's basically called a community.

V: Yeah, I mean, it's done with the fusion of your own dancing and the music that's being done.
BC: Well... I don't think that anything represents to me that Punk music has died.

V: You think it's died? [tape skips] You know, but they work, at least when I've seen them.

BC: I don't know, I was talking to Ted [Falcone, Flipper guitarist] the other night and I said, "Here's Ricky, and he's playing with Sleeper [*sic*] again; you think you're gonna lose him to Sleeper [*sic*]?"

V: Oh they've already—

BC: And he said, "We've already lost him." So where's Flipper, without Ricky?

V: Well they have Bruce Loose; he's pretty good.

BC: [*reluctantly*] Yes.

V: He's not quite as good?

BC: Well, no, but why is Ricky gone?

V: Why did he leave Flipper? Well I tell you, they just—he wasn't reliable, I guess.

BC: He?

V: Ricky wasn't.

BC: Well, he just didn't show up once in a while!

V: Right, exactly.

BC: They probably wanted him to be more dependable.

V: Yeah, and Bruce Loose would show up every time.

BC: He's not as loose!

V: No, he's not. [*laughs*]

BC: [*laughs*] I gotta talk to Ted about that, because that's a definite value failing.

V: Value failing?

BC: Yes.

V: What?

BC: Well, why the shit can't they have Bruce Loose *and* Ricky?

V: Oh, yeah!

BC: I mean hasn't he ever thought of that? Why can't they have Bruce Loose available, you know, or, you know, one of the other—I mean *shit*. Or somebody else instead of Will, if Will doesn't show up? Why does it have to be the same people?!

V: [*laughs*] That's funny. Well, I guess the Sleepers have reformed; it looks that way, if they can keep it together.

BC: Yeah. You know, one of the things I used to think of was like: a band when it plays should change its name every time it plays! Another one was to keep the same name and change the people every time.

V: [*laughs*] Either way. That's—yeah. Yeah, see, I'm glad to hear all this, because I'm trying to figure out if there were some ground rules that should kinda be used as standards, you know, for all this. And seems like—one of them should be that a band should never plan on lasting very long.

BC: Well...

V: I mean they should just plan *not* to last long.

BC: I'm peeing in the toilet, can you hear that? Can you hear my toilet here—

V: No, there's a huge fan going on here. You know,

the heating system is on. Very noisy. Takes out all the moisture in the air, dries out—

BC: The only *classic* band that I can remember—well actually there were two of them—

V: Well the Pistols, now, let's not—

BC: No, I'm thinking about something older than that.

V: Oh.

BC: I'm trying to remember what they were even called, because I never even liked them too much. It was a black group, in the fifties.

V: The fifties?

BC: Yeah… I can't remember what they're… I didn't like 'em. You know, it was one of those things where they had four black guys out there, singing.

V: The Impressions, or something?

BC: No, it was before then. This was really old. This was back in the time of the Coasters, sometimes they'd mix up the Coasters, too, but this was—who were these guys? You know, you've heard—they were famous. They were before the Coasters.

V: Anyway, they kept losing personnel?

BC: No, they had three or four of them! They were niggers, and nobody could tell one nigger from another! So they would send out these guys—

V: You're kidding!

BC: They would call them the plantations, too—I can't remember what the hell—

V: You mean there were three or four bands touring as them?

BC: Yeah, there were like three or four groups, tour— [tape skips] They were halfway between—

V: The old doo-wop and—

BC: Halfway between real doo-wop and…sort of forties something-or-other.

V: Oh God, I'm sure I must know them, jeez. Not the Drifters?

BC: You're getting close.

V: Well, I guess Fats Domino did "Red Sails on the Sunset"—

BC: That's only one person.

V: Yeah, but I thought there was another band that did that, too.

BC: Drifters is pretty close.

V: Yeah well—oh boy. Hmm…

BC: I could probably find it out real quick, I would have to look at—but the thing was that they had really like three touring groups!

V: [*laughs*] That's fantastic.
BC: And they were all being owned by, I don't know, Mo-

town, or King Records, or one of those—the plantation—
yeah, the plantations.

V: Exploitation.

BC: Yeah, it's a plantation number. You know, it was a
record company either run by whites or run by blacks,
that signed these people up so they got twenty-five bucks
a week, and they owned the name, just the way the Sex
Pistols are owned by McLaren, and he'll exploit them for-
ever, and, you know? They bank on the fact that nobody
could tell the difference between one nigger and another.
And they'd do the same song arrangements—nobody had
ever seen them on TV, so they didn't *know*, right? So they
would show up in Mexico City, and at the same time they
were playing in Rome, they would be playing in Atlan-
ta, Georgia and in Tokyo. There'd be four black guys up
there doing the *same* songs—

V: A real good band—

BC: Well, they're not a band, it was just a vocal thing, you
know, it was all arranged—a real good product.

**V: Well, maybe there's some more little suggestions
that can be evolved, maybe involving managements,
or—**

BC: No.

V: Nope?

BC: Nope. I think it's all impossible there. I think the ba-
sic thing is—

**V: All these Punk musicians are now getting better
and turning into studio musicians for hire—**

BC: Yep.

V: —with Old Wave musicians, you know; Danny and Denny [Punk musicians] just went with Jorma Kaukonen [Jefferson Airplane] to Europe. And Brian James and Glen Matlock with Iggy—

BC: One of the accusations about the Punk scene is that it's "elite." And that whenever anybody succeeds, everybody hates them! And everybody that's a musician is trying to succeed.

V: Keep going.

BC: And as soon as they succeed they become disdained, and somebody tries to find a new band.

V: I didn't think the idea was to become musicians anyway, like, in the sense of "technicians."

BC: Well, no, they don't necessarily want to become technicians, but they find out that's what they have to do.

V: What, to keep playing music?

BC: They have a choice between destroying themselves within an organization that offers them the chance to continue to play the guitar, or they're offered the chance to destroy themselves personally. I mean, there's your options: are you gonna go join the organization in whatever capacity that you can and still play an instrument, or are you going to continue to play your instrument on your own and then destroy yourself physically, emotionally, and mentally?

V: In other words, being in an endless series of Flippers kills you.

BC: [*pause*] No, I've never seen any endless series of Flippers! [*laughs*]

V: Well, I mean—

BC: I think Flipper is an extremely unique situation. I can't, you know, I can't quite believe that these people have *survived* as long as they have.

V: Yeah, it's pretty heartening, isn't it?

BC: 'Cause most of the people that I knew, in the sixties, didn't last that long.

V: In the sixties.

BC: Well—I mean in the sixties... They were probably more conspicuous, because they were in the limelight. You noticed Janis [Joplin], and you noticed Jimi [Hendrix], and you noticed all these other people, and then they conveniently died real quick. And then there were other ones that didn't die that quick. You know, where the hell did they *go*?

V: I don't know, I saw Chet Helms [sixties Family Dog founder] today in the street. He looked all right. His hair's a lot shorter—

BC: He never looks any worse than he did ten years ago. He looked awful ten years ago.

V: Anyway, he wasn't one of the "artists."

BC: Sam Arnold? You remember Sam Arnold?

V: Vaguely.

BC: He was with Big Brother.

V: Oh, Sam. You confused me, because you said—I thought you meant Sam Andrews.

BC: Is that who I meant?

V: Yeah, yeah, what happened to him? I haven't seen him in ten years.

BC: I haven't seen him for ages. However, I've run into at least three different people in three different situations, that have mentioned his name to *me*. I don't know where the guy is!

V: Oh, you mean they wanted to know.

BC: Well, they mentioned him, and they mentioned me in context with him—that somehow they *knew* that I knew who he was.

V: Well, so much for him.

BC: Yep, I don't know; he's wandering around somewhere! Some extra moon, circling around something, I'm not sure what.

V: What do you think about a band like Versus? I mean, they try hard.

BC: Well... [*laughs*] They should try hard every day.

V: What do you mean by that?

BC: Well, they should be rehearsing every day. I don't think they do.

V: Huh.

BC: Well there's also our favorite friend who's out there in front, who runs the band.

V: Who, Heidi [Crawford]? Or Indian? Or Olga [de Volga, RIP]?

BC: Olga.

V: What about Olga?

BC: Olga keeps throwing—you know, she gets to the point where she and most of the band are in conflict, and most of the band leaves. Or she leaves. You know, and then she starts another band. What was the band that she was in—oh she was in the Offs. And then she left the band, and I was disappointed that she left the band, because I thought she was a great person to have there. And people would say, "Well…." They wouldn't listen to her, they wouldn't want to do her songs, they didn't want to do this or that…. So she started her own band. And then the first band was—I don't know. There was Carola [Rosenthal] and there was all these people in there. And they wouldn't do her songs or something, or she wouldn't do *their* songs. And *they* all left.

V: Jeorgia [Anderson] and all.

BC: Yeah, I mean it was like four or five people, all at once, and they all leave, and then she starts another band. And they don't *really* improve. I mean there's always the germ of *building* something there. And I'm not quite sure whether Olga knows what she wants to get. I mean she knows what she doesn't like. And she rejects these people who are obviously conflicts in one way or another, but I'm not sure whether she's choosing more creative people to work with, time after time, or whether she's able to structure what she wants to do with the band. I like her. I

like the people in her band. But musically it doesn't seem to go anyplace. But you know, there's real energy or emotions involved. Of course I like the *emotions*.

V: Yeah, me too.

BC: So I like Versus. I like Versus, but musically and structurally, I'm very critical of it.

V: Yeah, maybe they don't have classic songs.

BC: Unfortunately.

V: Yeah, unfortunately, right.

BC: And individually I've met people that have real strong emotions, but it doesn't come out in the music. I don't know; it seems to me that most of the people in Flipper have a lot of strong emotions and they have some background in music, to the point where they can reject or accept things, and *choose* not to use those structures, and in a way, I think that the people that were in Flipper were cruder and more inept onstage, musically, than many people. But I really enjoyed them more.

V: Yeah I don't think of anyone that I enjoyed more than Flipper. Bob is another matter, 'cause it's really—it's real zaniness. I mean the guy was just—he looked like a real nut, a nut-o. It's hard to say—

BC: Well I've never met anybody like that, I'm sorry. I just don't wanna meet anybody that's a nut.

V: [*laughs*] Like I said—

BC: [*laughs*]

V: Like I said: he looked like Howdy-Doody gone berserk, the drummer. It was so weird that I liked it. Of course I've only seen them once.

BC: That may be the best way.

V: Yeah, what, one viewing only?

BC: Yeah, I don't know. Sometimes I think that the audience of UXA is the same audience.

V: What do you mean?

BC: Well, the same people are there. But the audience has never really increased that much. Proportionally, you know. Like there are bands that start, and they build up a bigger and bigger and bigger audience and sooner or later they—

V: But often it's through gimmicks, like Dead Kennedys.

BC: Well, they do have gimmicks, but there are at least—

V: They're a real powerful band—

BC: Two crazy people there.

V: What, in the Kennedys?

BC: Biafra is really a nut. He is insane.

V: Who's the second one?
BC: Well, I'm not quite sure who they are. It's probably the rest of the band for being on stage with him. [*laughs*] Yeah, well, you know, most of the gimmicks are there because of Biafra.

V: Yeah, that's true. They're all in there—

BC: And he's nuts, he's really crazy. And his last craziness was that it seemed like he was seriously considering carrying on his political activity and running for supervisor.

V: What, you mean—next time?

BC: That was the night when they had the elections, and then there was some kind of talk about him running for supervisor, I don't know. It was like he wasn't accepting or rejecting it and he was—you know, he was doing all the things that politicians do. I ran for supervisor, and in spite of what I was doing I found myself doing exactly the same thing that all these people do, and it was really interesting to do! And how you were put into these positions where you would meet very different people time after time, and you know—politicians figure it out, how they can shake hands and say this, and they move from one person to another. And I was really surprised at how well I was doing that, after a while! And I think that maybe Biafra was surprised, *also*, at how *well* it was working. You know? I don't think he actually got involved in the political process. I don't *know*, maybe he's gonna be out there, running for supervisor in another year or two. And amalgamating I don't know... Jane Fonda's gonna be over there campaigning for him.

V: [*laughs*]

BC: Who else should we trash this evening, on the telephone?

V: [*laughs*] Well didn't you encounter a number of conflicts, as a supervisor now? You know what— you found you were becoming codified?

BC: Oh yeah, there were people that called up and said they were gonna kill me.

V: Oh, oh, really?

BC: And there were people that were in the Haight-Ashbury who—

V: Why would they wanna kill you?

BC: I don't know, they—well…

V: You *do* know.

BC: They called up, and they said, "Hey, yeah, I wanna vote for *you*, and what is your opinion about this or that?" and then halfway through the thing they tell me that I'm a commie, and they're gonna kill me or, "We know how to take care of you people," and—

V: Oh, they were serious. Verbally serious, at least.

BC: It's a very hazardous activity. And then the Haight-Ashbury; I mean, the thing was that there were an enormous number of people running for supervisor. And it must have been like four or five people out of the Haight-Ashbury that were running. And I would find myself down there being treated like the absolute enemy of the world. Because there was some other—like a black guy that was running for supervisor, or whatever. "No, we don't want *you*." Whereas, as far as running for supervisor at the time, when you'd vote for supervisor you would vote for five or six people at one time. It didn't make any difference, it wasn't anything to do with *one* person or another, but… You know, I kept a very low profile. [*laughs*] And despite that, you know, I can't believe that anybody would really want to keep on doing it. When I think

about Barbagelata and all these other people who have been supervisors, I mean, they just have to be absolutely *fucked up* to do it. Because you know, people shoot bullets through their windows, and call them up and threaten them on the phone, I mean—you gotta put up with constant *terrorism*. We don't cope with it at all.

V: We do not.

BC: These guys do it all the time. Dianne Feinstein is not a comfortable middle-class person sitting in her home, collecting money and all kinds of other power things—I mean she wants power, obviously, but to go through the kind of shit that they're going through is really unbelievable. *I* can't do it. *I* couldn't do it again.

V: [*laughs*]

BC: No, it is extremely dangerous. I mean, people that you have never met in your life will wanna come up and beat the shit out of you for something that you never said and never did. Right?

V: Yeah.

BC: And it *is* vulnerable, because like, when you run for office, you have to put down your home address.

V: Anyone can look it up, huh?

BC: Anyone can come by. And they *do* do it. I don't know what Biafra did. Fortunately when I ran for supervisor, I *moved* to a new location between the time that I registered and when the booklet was published. But my phone number was still the same. So I don't know what those people had to deal with down on Carl Street, but the phone calls that I got until I disconnected my phone, from public dis-

closure into a private line, was [*sic*] enough to influence me to not be very public at all. My campaign is probably exactly the opposite of Mr. Biafra's.

V: Well, he *was* moving around; he didn't have any place to live.

BC: Yeah?

V: Yeah.

BC: What do you think, now; do you think that Jello Biafra and the Dead Kennedys are gonna be totally passé? The election's over; why should we even pay any attention to Biafra?

V: Well not for their fans. Actually a lot of people that voted for him had never seen the band, and they'll gradually get to see the band.

BC: Well we were a Jello family over here. We were a solid Jello family. Robert [son] couldn't vote. But I voted for Jello, and my wife voted for Jello.

V: Good. Didn't he get 6,519 votes?

BC: Something like that.

V: Yeah, that's pretty good. Not bad, you know.

BC: Well, you know, a lot—I don't know what it's been like recently, but when I ran for supervisor, there were only two contestants, really, and the number third got something like 650.

V: Oh, yeah? Where were you?

BC: Well, I wasn't running for mayor. The supervisor was a different matter.

V: Oh that's right, yeah.

BC: Because you could only vote for one mayor, but at the time you could vote for like five or six supervisors at once. So me and a bunch of other people made about 55,000—or 5,000, 6,000 votes. There were several of us. But at that time, they had like forty-eight candidates for seven supervisor chairs.

V: Forty-eight, Jesus Christ!

BC: And so like the top seven got the chairs.

V: Yeah right. But that dispersed a lot of votes, watered down a lot of votes.

BC: And there were about five or six other people that I was ahead of, but I was still like number forty, or something, down at the end. But I got 5,400 votes.

V: That's quite a bit.

BC: And in that range, there were probably about nine or ten other people, that got about 5,200, 5,600, 6,000 or whatever. But the winners had to get something like 95,000, 110,000. Now it's a little bit different. And it *is* very different because, like, Biafra kind of reflects an overall city vote that is comparable to what the supervisor's vote used to be, because now the local vote is much tighter. Like Biafra was getting votes from Castro, Market, North Beach, et cetera. It all added up because everybody was disenchanted with the mayor's vote. But they were *very* engaged in their district supervisor vote. Whereas in the past, the protest vote used to be the supervisor vote.

But everybody seriously considered, ten years ago, the mayor vote. So nobody threw away their votes running for mayor.

V: Yeah.

BC: So that's why like the third runner was getting like 625 votes; they really thought that it made a hell of a difference who was mayor. Now, **I don't think anybody thinks that whoever's running for mayor makes a hell of a fucking difference, anymore. Tweedle Dum, Tweedle Dee, and Tweedle Doo-Doo!** But most of the local supervisor things are gonna end up really tight, kind of right–left confrontations, or Tweedle Dum, Tweedle Dee confrontations, or no confrontations at all. I would expect that if Biafra was gonna run for supervisor it would be a lot tougher. I think he ought to run for mayor again.

V: Mm, yeah. [*laughs*]

BC: Because I think next time he's gonna get *more* than 6,500 votes. After a while they'll have to pay attention to him. But I can't think of any section of the city where you can get enough votes to actually become supervisor.

V: Yeah, right, exactly. [*pause*] So, oh boy...

BC: It's almost midnight. I got five more minutes according to my clock.

V: Oh yeah, I got six.

BC: Oh, do you know anybody that works like a secretary?
V: Oh hey, I have to ask *you* something—not ask you but tell you. Do I know—yes I know someone who does, why? What do you want?

BC: Well somebody's been coming over here and acting as a secretary for me, like, *occasionally*, almost once a week.

V: What do you mean, like, taking dictation, writing letters? Typing?

BC: Typing stuff, or adding things up. It's dumb work and has nothing to do with really being a secretary, it's just that I can't cope with—

V: Yeah I know what you mean. How is the pay, is the key question.

BC: Well the person that's been working with me is getting paid with artwork, but I think I don't want to do that anymore. Because I had a lot of things that I wanted to "cope with" tomorrow, and she called up at nine o'clock and said, "Golly, I gotta write up this proposal for National Endowment of the Arts, and I don't think I can come over." And usually I find that the best way to deal with people if they're gonna do something is: they actually have a job and they're getting paid.

V: Yeah, right. Oh you mean cash, good old cash.

BC: Real money—

V: Real money.

BC: And my problem is that I have to deal with some things emotionally that I have a lot of trouble with, and I have to do it all by myself. I'll probably have to do this stuff tomorrow all by myself.

V: Yeah, well that's me, trying to collect for past *Search & Destroys*; I can think of every reason not to write a letter to New York or Milwaukee or

wherever.

BC: It's a disgrace, because there's no reason for you to do it in the first place.

V: Yeah, they owe us the fucking money. They earned it, long ago.

BC: Well, I don't know; there does seem to be a reticence to publicize these things, and one of the things with Canyon Cinema, which I tried to promote, which now seems to be impossible, because it's so integrated into bureaucracy, was to publicize when somebody fucked you over.

V: Yeah, yeah.

BC: And it used to be like they would print these letters; somebody would say, "This asshole has done such and such-and-such," and then the *asshole* would write in a letter—

V: Defending himself.

BC: Defending himself, and his letter might be two pages longer than the first letter, and then they would have a reply, but— [tape suddenly ends]

●　　●　　●

AFTERWORD

While working at City Lights Bookstore in San Francisco (1968–1984) I met a lot of artists, including Bruce Conner who was introduced to me by an SFAI student named Susan. When Punk Rock finally happened in San Francisco (1977), I persuaded Bruce to take photos for my *Search & Destroy* magazine by offering him a press card—immediately he would be part of the *S&D* "In Group" and not have to pay admission to the Mabuhay Gardens, the reigning underground club. Bruce told me that he'd always wanted to be a combat photographer, and now finally he'd gotten his chance. A lot of early Punks didn't know who he was, but anybody proving themselves to be "hardcore" by showing up every night eventually became accepted by the vanguard (remember, it took almost two years for San Francisco to develop a "scene" of just 200 people who knew each other's names—in a city of 750,000). Friendships formed during that start-up period seemingly had staying power till death. Bruce Conner played a chameleon throughout the Beat, hippie, and Punk movements, all the while exploring genres while creating a multi-faceted artistic legacy. Conner's body of work is so enigmatic and conceptual that it leads us to conclude that for the twentieth century, the three most *original* artists were Marcel Duchamp, Andy Warhol, and Bruce Conner.

—V. Vale, historian

MOVIES
AT THE
A HOLE
527 THIRD ST.

SATURDAY APRIL 19, 1980 9 PM

$1.

Films by: **BRUCE CONNER GUNVOR NELSON MARK STERNE BILLY BASTIANI DOUG HAYNES LARRY WHITE MICHAEL CONNER DANA JARAMILLO MARIAN WALLACE ERICH BROGGER** and **UNITS TRAINING FILM**

The *real* premiere of Conner's film: *America Is Waiting* was at punk-performance venue A Hole Gallery in San Francisco. Show programming and flyer by then-SFAI art student, Marian Wallace.

S tarting in the Punk Rock Seventies, V. Vale sporadically tape-recorded Bruce Conner talking, usually in the afternoons. Uncensored and playful yet revelatory and insightful, these conversations reveal Conner as a man and artist committed to escaping any attempts to predict, categorize and define "him" and his art—he had a protean identity relentlessly seeking freedom and spontaneity of inspiration. These conversations have never been transcribed until now. With an admirably lucid introduction by Natasha Boas, this volume presents Conner as more relevant than ever for today's new generation of artists. Artist and filmmaker Marian Wallace speedily designed the cover and produced the book just in time for the Bruce Conner retrospective opening at SFMOMA October 29, 2016!

● ● ●

V. Vale was an early member of the "father-of-heavy-metal" band Blue Cheer until they downsized to a power trio, July 15, 1967. He was mentored by Philip Lamantia, William S. Burroughs and J.G. Ballard. With $100 each from Allen Ginsberg and Lawrence Ferlinghetti in early 1977, he started the first "Punk Rock" publication in San Francisco, *Search & Destroy*. In 1980 he launched RE/SEARCH (a pun on *Search & Destroy)* and for almost forty years has published from his home office just uphill from City Lights Bookstore and the Beat Museum in the storied North Beach neighborhood of San Francisco. His best-sellers include *The Industrial Culture Handbook, Modern Primitives, Pranks, RE/Search #4/5: William S. Burroughs, Brion Gysin and Throbbing Gristle.* His *Incredibly Strange Films* and *I.S.Music* books inspired the reissue of countless obscure movies and vinyl recordings. V. Vale also plays piano, gives lectures, and is the host of the TV talk show *The Counter Culture Hour.*

BRUCE CONNER LUXE VALUPAK

Get every appearance of Bruce Conner in *Search & Destroy* and RE/Search. Deluxe box contains *Search & Destroy* Issues #5, #6, #7, #8, #9, #10, #11; *RE/Search #11:* Pranks deluxe hardback (only 500 made); and four small color prints of Bruce Conner.

Call or email for details.

RE/Search Publications
20 Romolo Place #B
San Francisco, CA 94133
(415) 362-1465
info@researchpubs.com
www.researchpubs.com

Printed in the USA
CPSIA information can be obtained
at www.ICGtesting.com
JSHW010732170424
61324JS00004B/6